ALAN MCCREDIE has been a freelance photographer for a decade, working with most major agencies in Scotland and beyond. He has specialised in theatre and television but is perhaps best known for his documentary and travel photography. A member of Documenting Britain photo collective, he is a Perthshire man lost to Leith.

100 *Weeks of Scotland* was initially an online project in association with *The Scotsman*, documenting all aspects of Scottish life in the two years before the independence referendum. His first book, with Daniel Gray, was *This is Scotland: A Country in Words and Pictures*.

www.alanmc.co.uk
@alanmccredie

Prints of all images in this book and in This is Scotland are available to purchase at www.alanmc.co.uk

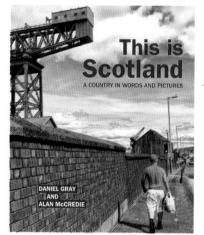

ISBN 978-1-910021-59-0
£9.99

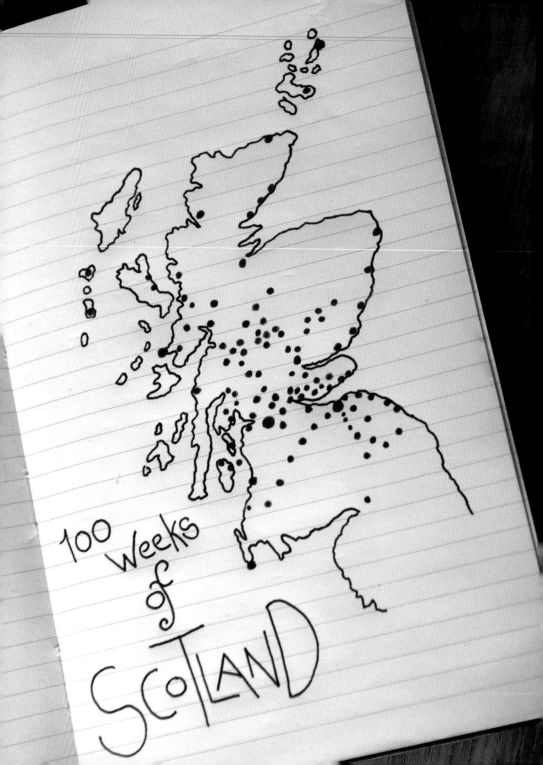

100 Weeks of SCOTLAND

100
Weeks of Scotland

A Portrait of a Nation on the Verge

Alan McCredie

Luath Press Limited
EDINBURGH
www.luath.co.uk

For my brother, Kenneth,
who flew,
and always will

First published 2015

ISBN: 978-1-910021-60-6

The paper used in this book is recyclable. It is made
from low chlorine pulps produced in a low energy,
low emissions manner from renewable forests.

Typeset in 10.5 point Quadraat by 3btype.com

Printed and bound by
MBM Print SCS Ltd., Glasgow

Introduction

IN OCTOBER 2012, I was searching for a project. Something different that would complement my everyday work as a professional photographer. Something I was interested in. Something small scale that wouldn't take too much time. We had a teenage girl and a two-year-old boy, so time to spare was a distant memory.

And then while watching a news report on the signing of the Edinburgh Agreement by the First Minister Alex Salmond and Prime Minister David Cameron, which sets out the roadmap of the independence referendum, a voice came from the TV which said something like: '... for the next 100 Weeks, Scotland...' It was the spark I was looking for. Once I had the phrase '100 Weeks of Scotland' in my head, I couldn't shift it. I knew I had found my subject.

For the next two years – the next 100 weeks – I travelled as far as I could and saw as much as I could. I dread to think what I spent on petrol but I know the total mileage would take me comfortably around the globe.

I wanted to make a portrait of everyday Scotland in the tumultuous run-up to the referendum. I didn't want to cover the political events that would so dominate the news media's view of the country; I wanted to photograph the Scotland in which we all live, and to make an attempt to try to find out what we all thought about the times we were living in.

What I discovered was a country made up of people from all over the world, who live and work here and who were given a chance to have their say in how the place they live should govern itself. Civil wars have broken out for less, but we, in this small part of a small island, could do it with the stroke of a pen. It has been an utterly remarkable period in the history of Scotland, one that I am so glad I could live through, and document.

Alan McCredie
Edinburgh, October 2014

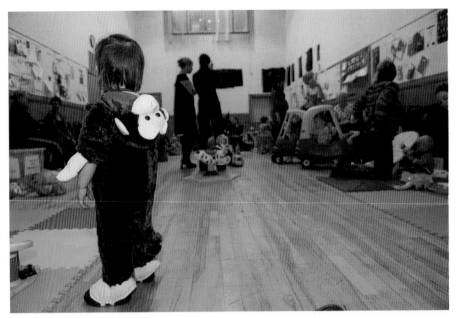

WEEK 1 | Edinburgh nursery

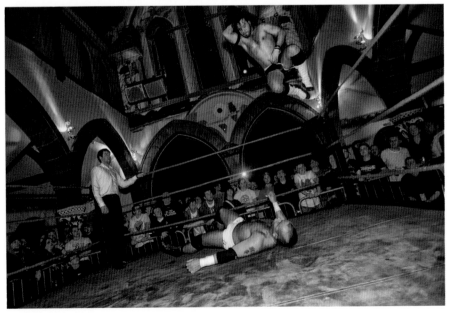

WEEK 1 | Wrestling at Oran Mor, Glasgow

WEEKS 1–5

October to November 2012

IT IS A BITINGLY cold Edinburgh evening on the last day of October 2012. I have just been photographing the Samhuinn Fire Festival on the Lawnmarket when I bump into a friend just off the Royal Mile. He asks what I am up to, nodding at my camera. I tell him about my plan to photograph the 100 weeks that run up to the independence referendum and he just laughs. That's quite a *big project*, he says. This undeniable truth has been dawning on me in the few days since I started this process, at Oran Mor in Glasgow, photographing a celebrity wrestling match organised by the actors Greg Hemphill and Robert Florence. Now, as the wind whips through the closes and alleys of the Old Town, I am beginning to realise the scale of what I have taken on. This is, without doubt, *a big project*, but one I am reasonably sure will be straightforward. It's just a few photos every week. Easy. Just make sure I have my camera with me and everything will be fine...

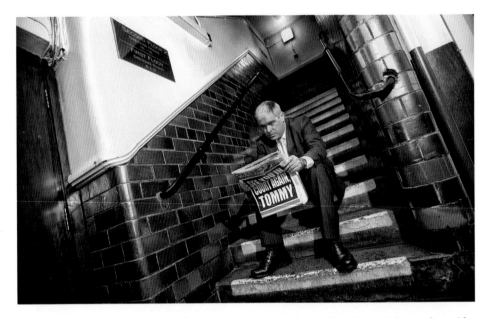

WEEK 2
Des McLean as
Tommy Sheridan in
I Am Tommy, King's
Theatre, Glasgow

A week later, and everything is not fine. I am, it has to be said, happy with my initial three images – three different events, two different cities. I am doing ok. However, as I progress into week two, I am struggling. I am still trying to work out exactly what I want to achieve by carrying out this documentary, while also attempting to solve the more pressing problems of what exactly to photograph for my second week.

Still, it is early November, so I know there will be something visual to photograph on Bonfire Night. Once again I find myself in the cold dark of an Edinburgh evening. This time I am up on Arthur's Seat, looking down on Meadowbank Stadium. I have climbed quite high and it is only when the fireworks begin that I realise I am actually above them. It had never crossed my mind to check just how high fireworks fly, and as it turns out, it was a lot lower than I had imagined.

The fireworks diminish and a day or so later I am heading to Glasgow and the Edwardian splendour of the King's Theatre for *I Am Tommy*, a play based on the rise and fall of the politician Tommy Sheridan, featuring the actor and comedian Des McLean, who I photograph on the beautifully tiled staircase backstage.

Sometimes, a portrait is just about the sitter, and nothing else

8

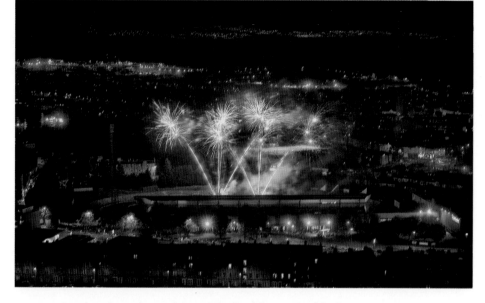

matters. At other times the setting and the backdrop can add a lot to the shot. The portraiture I prefer falls into the latter category – the subject is the most important element, but I always try to get as interesting a background as possible. Behind-the-scenes shots always work well and the King's Theatre does not disappoint.

The first two weeks are now complete. I haven't ventured further afield than Edinburgh or Glasgow – two tiny red dots on a map that is overwhelmingly grey. A map that over the next 98 weeks will, I hope, gradually fill up, small red dot by small red dot.

It is now that I sit down and really think hard about what I want to achieve. With just under two years until the referendum, I know Scotland is entering a period of flux. Politically, the next few years will be dynamite, with the 300-year-old union of the United Kingdom on a shoogly peg. Yet, despite all of this, people will be carrying on their daily lives in the same way they always have done. For the next two years the extraordinary will exist alongside the ordinary.

I want to look at the lives of the people of Scotland over this time of political upheaval. I hope by looking at the smaller picture – that by the examining the everyday – the larger picture will come into sharper focus. Politics in this instance is not an abstract

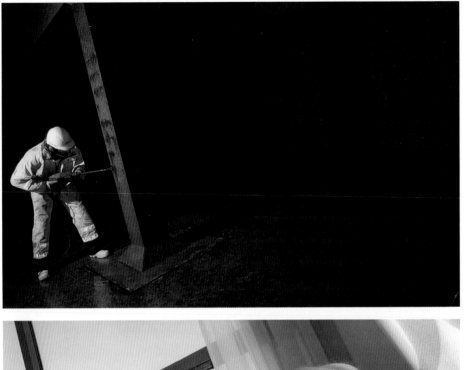

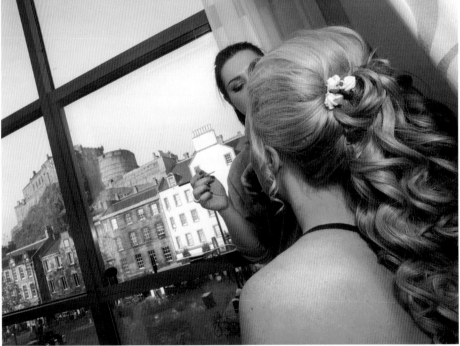

concept – what happens over the next 98 weeks will have repercussions that echo throughout the decades and centuries to come. Scotland sits on the edge of the unknown, and will for the first time in a very long time have to look long and hard at itself. I think it may be quite startled by what it sees looking back.

WEEK 3
Underground reservoir, Canglour Wood, Stirlingshire

A few miles to the west of Stirling, at Canglour Wood in the rolling farmland that undulates all the way to Loch Lomond some 30 miles distant, there is an unassuming house in an unassuming field. In the field are two shallow mounds and it is on the larger of these that I now find myself, peering into the inky blackness below as I slowly descend the iron ladder. The light on my helmet picks out a large chamber, and as my eyes become accustomed to the gloom, more is revealed. A space the size of two tennis courts, studded by a dozen or so columns, stretches out before me.

Not many minutes before, I had peered down through the service hatch above and this entire space was filled with thousands of gallons of water so pure and clear that, were it not for the occasional gentle ripple on the surface, you would think you were staring into an empty space.

I am here to photograph the regular cleaning and checking of the inside of these vast reservoirs by workmen, who tell me how completely ridiculous it is to buy bottled water in Scotland when the water we have is incredibly pure. Now that the water has been drained, I am standing in the centre of the reservoir as the workmen inspect the walls and columns for any structural problems. The flashing beams of light, momentarily bisected by the columns, pick out the masonry on the far walls and the workmen, who are busy removing any build-up of residue on the walls.

These hidden underground spaces are incredible structures: some are concrete boxes built in the 1950s and later, while others, usually those in the best condition, date back to Victorian times. They boast vaulted ceilings and ornate columns, which gladden the heart at the time, effort and craftsmanship that undoubtedly went into them, despite the fact that they were never intended to be gazed upon.

Back home in Edinburgh and I am due to photograph a wedding, something I do as rarely as possible and usually only for friends, or friends of friends. As I photograph the bride getting ready for her big day, the curtains in the hotel room are thrown

WEEK 3
A wedding in the Grassmarket, Edinburgh

WEEK 4
Dave Anderson

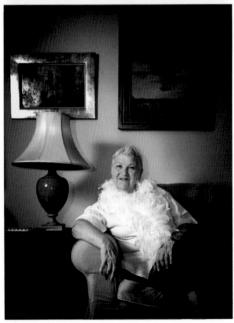

WEEK 4
Eileen McCallum

open by the make-up woman and a wonderful view of the castle is revealed. There are many beautiful views in Scotland and beyond but this view, looking over the Grassmarket towards the Castle on the hill, will always be one of my favourites.

I am most at home when I am photographing people. I find it the most rewarding form of photography and also the most challenging. Much of the time photography can be a reasonably solitary process. Hours can be spent in the studio photographing bottles of whisky, pints of beer and so on. All perfectly valid, but nothing compares to the feeling of doing a great portrait for someone

I have always loved the theatre and have photographed many actors in my time, so when I get the chance to photograph three of Scotland's finest actors, I jump at the chance.

WEEK 4
Maureen Beattie

Once again I am backstage, this time at the Royal Lyceum in Edinburgh to photograph the immensely talented Maureen Beattie, before heading to Glasgow and the rehearsal room for the hugely successful 'A Play, A Pie and A Pint' series of shows to photograph Dave Anderson, founder of Wildcat Stage Productions and one of Scotland's finest actors and musicians.

Finally, I photograph Eileen McCallum and the location is her Edinburgh flat. A hugely respected actress, Eileen has been at the forefront of Scottish stage and screen for over 50 years now, and is showing no sign of slowing down whatsoever.

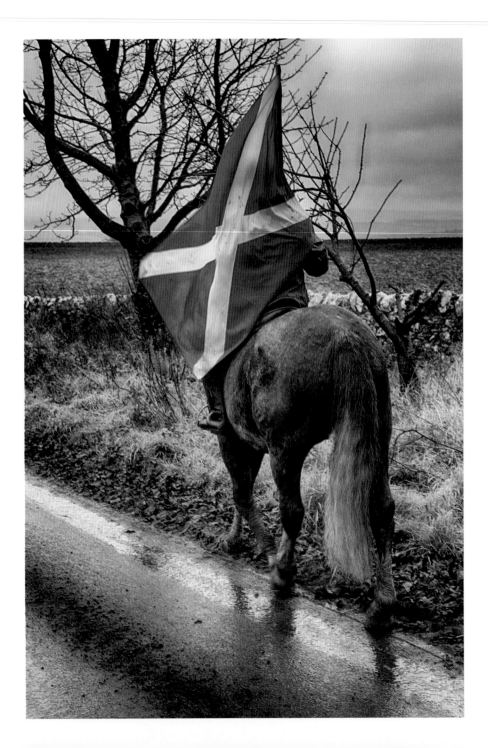

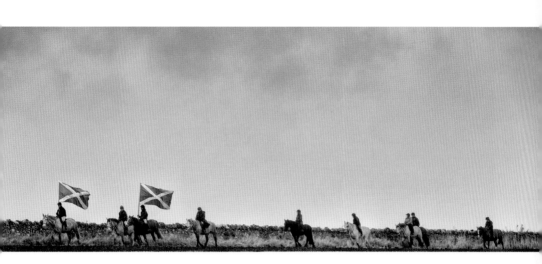

Waiting. I have been here standing in the mud of an East Lothian field for well over an hour. The wind is whipping the branches of the trees, which border the area of farmland where I am. A light but persistent rain falls. I have been promised the riders will come this way and that if I stand here I will see them on the ridge ahead of me.

Time passes, yet the rain does not. Suddenly, from far away, sounds can be heard. There are low shouts on the wind and slowly the noise increases until the horsemen appear. They carry two large Saltire flags. They have come over the hill from Athelstaneford, where legend has it that in 832 AD, the Saltire flag (possibly the World's oldest) was first adopted. The story goes that the Pictish king, Oengas, was visited in a dream by St Andrew on the eve of a battle against an invading army of Angles. The following morning the clouds formed a diagonal cross in the sky (St Andrew was crucified on such a cross), the battle was won and the Saltire was born.

The riders pass, the horses carefully picking their way through the mud toward the nearby road that will lead them away from these exposed slopes down to the lower land ahead and their destination, Haddington, where the flag will be raised outside St Mary's Parish Church as part of the 4th Saltire Festival.

WEEK 5
Saltire Festival,
East Lothian

WEEK 6
Norman, Edinburgh

WEEK 6
Eilidh, Edinburgh

WEEK 6
Gary, Dunfermline

December 2012 to January 2013

THE DAYS PASS and we are now into early December 2012. I have been publishing my images online week-by-week and the project is slowly beginning to pick up some followers and is generating a little bit of a buzz. There has been coverage in a national newspaper, although most of the comments seem to be on whether or not I will be able to keep the project going for two years. I have an entire country to photograph – I could spend the rest of my life working on it and still not see it all.

For week six of the project I decide to photograph more people. I make a few calls to those I would like to photograph and whom I think would be willing (surprisingly, very few people say no to having their portrait taken). I want to photograph them in their natural environments as much as I can, be it at home or at work. I always feel slightly apprehensive before taking someone's portrait. You never know quite what you are going to get and to take a photo that both the sitter and the photographer are happy with can sometimes be a challenge.

It is very early in the morning (or very late at night) when, in the winter darkness, I get into my freezing car and pull away from the kerb. I squeeze past the row of silent cars parked on the narrow street where I live, the diesel engine seeming as reluctant to get going as I am. Before long I am out of Edinburgh and heading north. The faint glow to my right becomes slowly brighter and stronger and as I speed through a Perthshire morning, the sun finally breaks over the horizon and lights the way ahead in horizontals of red gold and shadow.

I am headed to the northernmost tip of the mainland of Scotland, Dunnet Head. I've looked at the map, punched in the

WEEK 7
Dunnet Head,
Caithness

destination to my sulkily unresponsive Satnav, and filled a flask with coffee. The Satnav informs me that my drive will take seven hours, which seems an impossibly long time – I've checked the map and it barely looks any distance at all. Up through Perth, a quick run to Inverness, then up through Golspie and Helmsdale to the north point.

Seven hours later and I concede – the satnav did not lie. Even on quiet, early morning roads it is a long trip, made worse by the fact that due to other work commitments I have to get there and back in a day. I give myself a couple of hours to get the photos I need, and on a beautiful winter's day like this it proves to be more than enough time. The Pentland Firth, blue and cold, stretches for ten miles over to Orkney and the island of Hoy. The herring gulls swoop and soar on the salty wind as I explore the area and stand looking north, with an entire country at my back.

A storm hits the east coast of Scotland just before Christmas. A highly unusual combination of southeasterly gales, low pressure and high tides in the North Sea cause severe disruption and flooding in Scottish coastal areas.

North Berwick is hit particularly hard, with storage containers and 100kg boulders being thrown around as if they were Lego. The sea wall in the East Lothian town is badly damaged and needs to be repaired quickly, as more bad weather is forecast. As I walk down to the harbour, this lovely little town is looking a little forlorn and a little battered. There is a lot of damage and twisted metal. Debris scatters the concrete car park where once an outdoor swimming pool lured swimmers into its icy embrace. Like all coastal towns, though, this is just another storm and just another winter. The harbour wall will be repaired and the North Sea will be kept at bay for a while yet.

Located on the River Forth some

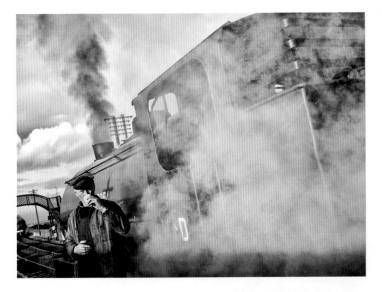

WEEK 8
Bo'ness and
Kinneil Railway

WEEK 9
Christmas in
Edinburgh

30 miles to the east, upriver from North Berwick, lies Bo'ness, another coastal town. Sheltered from the worst of the weather by its distance from the North Sea, the town is exactly as it should be on the Saturday before Christmas: manic. I avoid the shoppers and instead make for the station, home of the Bo'ness and Kinneil historic railway line. This wonderful old station has featured in many period films and is alive with the smell of engine oil and coal, and with the sound of steam whistles, locomotives and hundreds of children. They are here to ride the Santa express train, aboard which the great man will dish out presents as our steam train puffs, wheezes and clanks its way through the West Lothian countryside.

 Back down the river again to

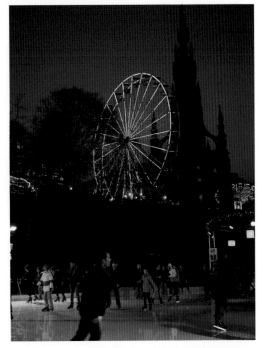

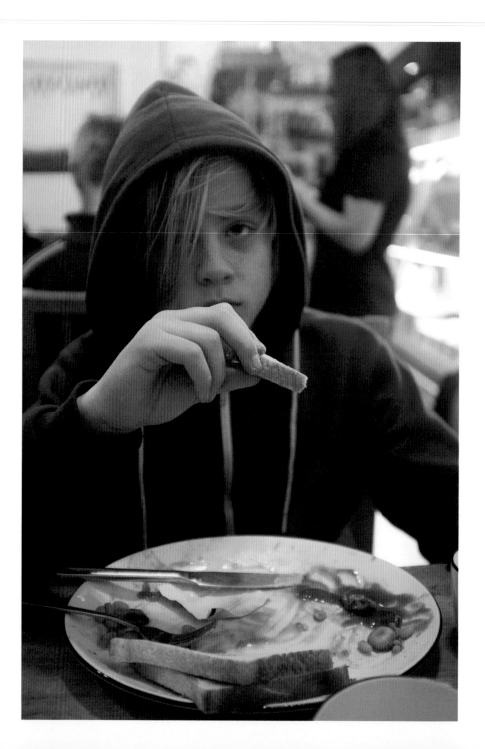

Edinburgh, which is, as every year, sparkling with winter festivities. Princes Street Gardens is home to market stalls and fairground rides. A big wheel rises adjacent to the towering Scott Monument and tens of thousands of tourists are here for the festive period, which culminates in the Hogmanay Street Party. The ice rink is always a huge attraction and although there are no skating ministers when I pass by, the good citizens of the Capital are out in force on the ice.

WEEK 10
All-day breakfast at 10pm, Edinburgh

It is the day before Hogmanay now and a torchlight procession is making its way through the centre of Edinburgh. The streets are busy with people heading into the centre of town to take part, and the smell of whatever incendiary material is used for the torches is hanging heavy in the night air. In a café on the Royal Mile a teenage boy eats a full breakfast. It is ten o'clock in the evening.

As the current year comes to a close, the procession begins and the torchbearers make their way slowly through the Old Town, over the North Bridge, spanning the jumble of railway lines that connect Waverley Station with the rest of the world, and finally culminates on Calton Hill where, to the north across the

WEEK 10
Hogmanay Torch-light Procession, Edinburgh

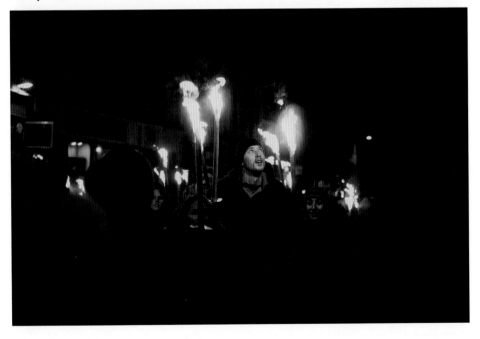

dark River Forth, the streetlights of Fife mirror the burning torches of Lothian.

WEEK 11
Snowfall in
Aberdeen

It doesn't take long for the first snow of the year to fall. 2013 is only a few days old when the first significant snowfall occurs. I am in Aberdeen when it begins and within a few hours it is reasonably deep and gives the city that strange quiet that so often occurs with fresh snow. All sound seems to be muffled. Everything slows down and it feels as if the city is preparing for hibernation. I however am not, as I have to get to Aviemore this evening and a long and twisty journey has just become a lot more interesting, and a lot less fun.

I make it to my destination after a very unpleasant drive. The snow caught in my headlights gives the dizzy feeling that I am in space, travelling at warp speed, with all the 1960s special effects of the *Star Trek* opening credits. The roads are open but only barely, and after several exhausting hours, definitely not at warp speed, I make it to my hotel near Aviemore, utterly exhausted.

WEEK 11
An inversion on the
Cairngorms

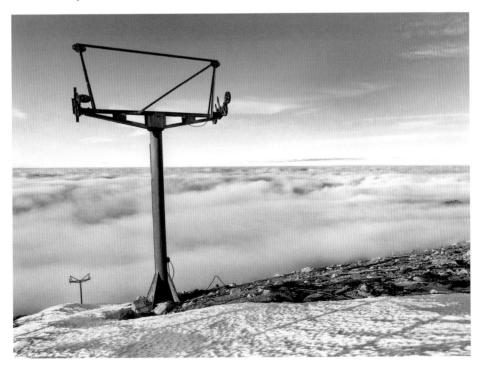

In the morning it has all been worth it. My plan was to head to the Cairngorm Funicular Railway and get some images from the top. 'No dogs,' says the particularly unpleasant attendant. Annoyed, yet even more determined, I decide to walk to the top. Or rather, the dog does, whereas I on the other hand trip, crawl, stumble, slip and finally drag myself up to the café at the top end of the cable car line. I started my climb in thick cloud, and three-quarters of the way up, suddenly and to my complete surprise, emerged above the clouds into brilliant sunlight. 'An inversion,' I am informed by a climber (I want to say fellow climber, but that would be very unfair to him), where warm air is trapped by a layer of cold, and clouds cannot rise vertically.

It is a stunningly beautiful phenomenon. Most of the skiers, climbers and walkers are clearly uninterested, having seen the effect before, but to see it for the first time really is quite magical. My dog, too, is completely blasé about the whole thing, as by now she has very definitely caught the scent of sausages and bacon drifting over from the Ptarmigan Restaurant, the highest restaurant in the British Isles (with the wonderful address of Cairngorm Mountain, Aviemore). I buy her a couple of sausages and as she devours them I sit on the terrace with my coffee, looking out over an ocean of cloud below my feet.

Back home to Edinburgh where the wet sands of Portobello Beach are home to legions of dog walkers. The weather is so clear that beyond the twin chimneys of Cockenzie Power Station, Berwick Law is clearly visible, some 20 miles distant.

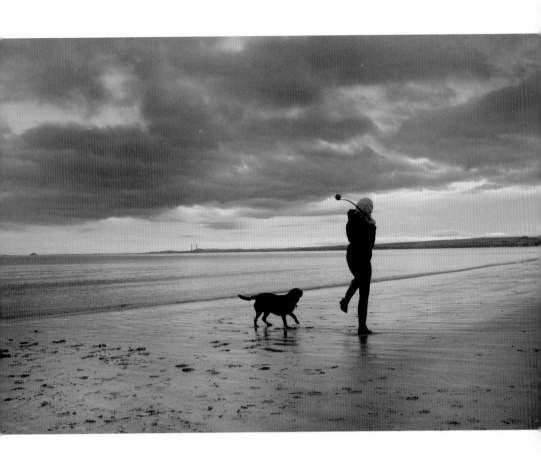

February to March 2013

AS ALWAYS, work comes calling and a few days later and I am out on a photo-shoot in Govan. The snow has gone, if it was ever here at all, and the temperature feels almost spring-like. Spring-like for Scotland, that is, although the youth of Govan seem completely unfazed by the cold anyway. Govan is one of the places I have on my list for this project, but today is not the day to do it – I have only an hour or so here before the photos I have been taking need to be with my client in Edinburgh. Work places demands on us all, and I have no time to linger.

Luckily, though, I arrive 20 minutes before my shoot is due to start and take the time to have a quick exploration of the local streets. It's quiet, but I soon spot three lads sitting on some steps. I ask them if I can take a quick photo, which they are fine with, and instantly they go into character. Usually, in fact almost

WEEK 13
The Govan lads,
Glasgow

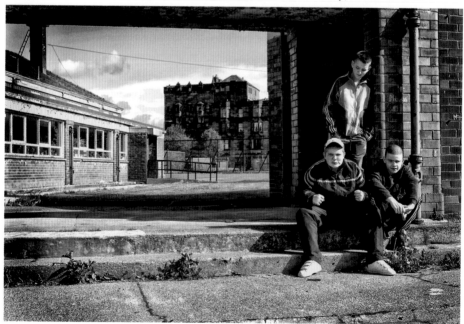

always, I prefer to capture people acting completely naturally. The very act of pointing a camera at someone, however, usually makes this impossible. The phrase 'just act natural' is almost impossible to deliver on. However, the three Govan lads quickly get bored of posing and the image I take is of them as they are, and it is really all I could have asked for. Even at this early stage of my project I suspect I will be lucky to get a better shot. Sometimes all the planning in the world can't rival a spur-of-the-moment event. In this, photography is no different to any other facet of life – you make your own luck, and often it can make you, too. If you're lucky...

One of the pleasures in doing a project like this is that I now have the perfect excuse to visit all the areas of Scotland I have always wanted to see. The Ardnamurchan peninsula is a perfect example. Years ago I read Alasdair Maclean's beautiful account of life in a crofting community in his book, *Night Falls on Ardnamurchan*. On another occasion I sat on a Mull beach as evening came, looking out over the water to the darkness engulfing Ardnamurchan and once more felt the pull.

WEEK 14
The foghorn at Ardnamurchan Point

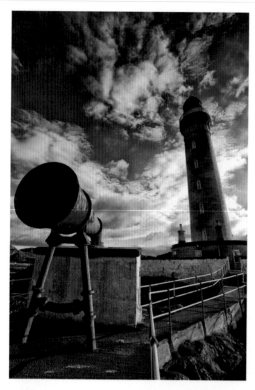

WEEK 14
Ardnamurchan
Lighthouse

Years have gone by since then, and as I drive my car onto the Corran Ferry for the short trip over to the peninsula, I am as happy to be here right now as I would be anywhere else on the planet. The mountains before me look quiet and tranquil in the soft morning light. One of the ferry-hands assures me it will be glorious weather. The ferry berths at the slipway and I am quickly on my way, past the old Corran lighthouse on my left, into the wilderness. Into the west.

First and foremost I have come here because this is the most westerly point on the Scottish (and British) mainland. Ardnamurchan Point, with its lighthouse, is about half a mile from Corrachadh Mòr, the true westerly point. I trudge over the rough ground to the point and stand for a while looking west towards the Atlantic Ocean, as so many must have done before me.

I return to the lighthouse to take some photos. The low winter sun picking out the contours and the ridges in the land makes for ideal conditions. I am the only one here and the only sounds are the seabirds, the waves and the wind. Occasionally a low moan can be heard as the wind brings the old foghorn to brief life. It is only a pale shadow of the sound the foghorn once made, but its melancholy note is a perfect accompaniment to nature's backbeat.

With almost comical timing, when I return to the car and try to start the engine, nothing happens. The sun is sinking slowly and the colour and the light are bleeding from the land all around. I try again. A cough and a splutter and the dashboard suddenly resembles an '80s arcade game, with every light flashing and an insistent beep telling me, in case I hadn't realised, that something isn't quite right.

I am possibly in one of the remotest parts of the UK. I haven't

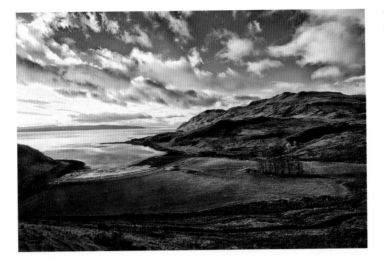

seen another human being for hours. I passed a few houses some miles back, but as it's getting dark, I don't really fancy the walk. I could always phone the AA... if my phone reception hadn't disappeared many hours back. There is only one thing for it. I pop the bonnet, prop it open, and stare utterly mystified at what I see before me. I tap a few things, mutter to myself a bit and replace the hood. I give the front tyre a hefty kick as I walk past. I try the

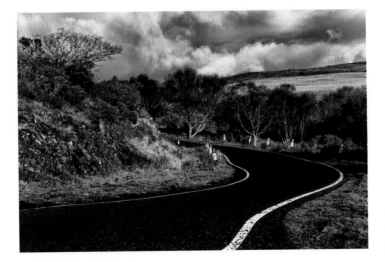

ignition again, and without missing a beat, the engine starts. The dashboard is as quiet and well-ordered as a limpid pool. I am fairly sure it was the kicking of the tyre that did the trick.

I don't hang around and head nervously back along the narrow road to the bright lights of Grigadale (population: ten). The road widens to give me about a foot on either side and I feel like I am on a superhighway. The car behaves, and before long I am well on my way through the quiet villages of Kilchoan, Salen, Glenborrodale and finally Strontian, where in the hills to the north the element strontium was first discovered.

I have spent only a day, in reality only a few hours, in Ardnamurchan and I have already fallen for the place. It is lovely and remote, but there is something else here, something indefinable that flutters at the edge of thought, which I know will bring me back here one day.

Away from the dream worlds of Ardnamurchan and it is back to the reality of life. I am now well into my project and it is beginning to take on a life of its own. *The Scotsman* has been in touch to serialise it on a weekly basis. I now have a firm deadline every week when they need the images and the accompanying words, and this is the best thing that could have happened. Like so many, it is a looming deadline that so often sparks me into action.

I crisscross the central belt. I am in Ayr as the sun sets behind the harbour. I am at the Loch of Lindores in Fife on a fine winter's

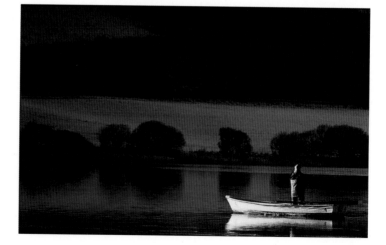

WEEK 15
Loch of Lindores,
Fife

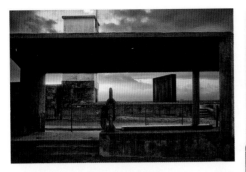

morning to watch the fishermen out on the water. On Buchanan Street in Glasgow, a boy circles the old police box in the hope that possibly, just possibly, it may actually be the Tardis.

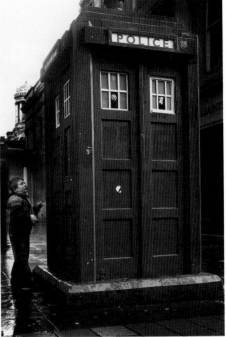

Now it is a cold and wet Saturday night in Edinburgh. Down a quiet street the lights of a fish and chip shop illuminate the greasy pavement. It is a beacon in the dark. Inside it is warm, and people scurry through the door to escape the damp. No vinegar on these Edinburgh chips – it is that strange brown sauce so beloved by the people of the Capital that coat these fried

WEEK 15
Ayr harbour

Police box in Glasgow – the Tardis?

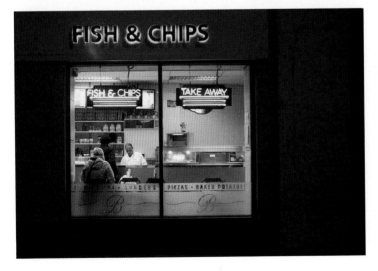

WEEK 16
Fish and chip shop in Edinburgh

potatoes. I've lived in Edinburgh for years and I still can't stand the stuff. I'll never be accepted till I do. I pass by the same shop a few days later and it is dark. Boarded up. The last fish battered and the last chip fried. I wander off, thinking of eulogies for fallen fast food shops, but can only come up with 'frying off to bluer skies' so I stop and go home instead.

In a function room, through the back of a large bar in Musselburgh, a fancy dress party is in full swing. In a far corner I am fairly sure I can see Mary Poppins getting very personal with Alex from *A Clockwork Orange*. Katy Perry stumbles past to say hello before wandering off on her merry way. At one point I am convinced I am talking to The Joker only to be huffily informed that I am actually talking to one of the members of Kiss. He can't remember the name of who he is supposed to be but 'it's the one with the big tongue'. I think for a second that the even the barman is in costume, but on closer inspection he is no Wolverine. He is just hairy.

I ask the host of the party (I pray he is dressed as Harry Potter and not Heinrich Himmler) if I can take some photos and end up being stuck there for quite some time, such is the desire of the partygoers to be photographed in their post-apocalyptic finery.

An altogether more tranquil fancy dress event is taking place at the National Museum of Scotland. Every so often a party is laid on to mark the launch of a major new exhibition. As the forthcoming exhibition is on the Vikings, this is the theme for the event and the crowds that mill round the lovely old building reflect this. Horned and bearded warriors sip glasses of Chardonnay, and blonde pigtailed Scandinavian wenches check their phones and queue up for the optional face painting. Bands play, and dancing girls circle the balconies above like

WEEK 17
Fancy dress party,
Musselburgh

WEEK 18
National Museum
of Scotland,
Edinburgh

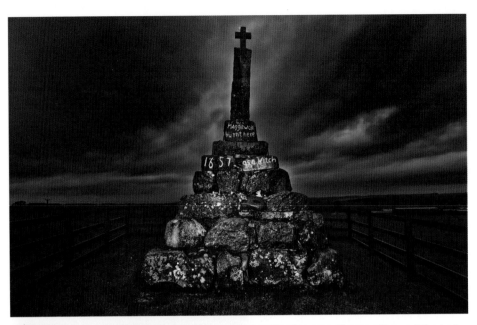

Valkyries. It's all great fun and Potter/ Himmler would have been in his element.

By the side of a quiet B Road, a few miles to the east of Dunning in the rolling Perthshire countryside, stands a monument with the inscription 'Maggie Wall burnt here 1657 as a Witch'. I have photographed here before but have returned to see if any changes have occurred in the five or so years since I last visited. Nothing is different, and the inscription looks as fresh and newly painted as before. Exactly who keeps those words freshly painted is as much a mystery as the identity of Maggie Wall herself. There is no historical record of her, and no information as to when the monument was built or by whom.

When I was a child, playgrounds were frankly terrifying places. If you survived being catapulted from broken swings onto cracked tarmac, dodged the broken glass and avoided being decapitated by the strange battering-ram-like metal horse ride, then the ever-present threat of getting your head kicked in seemed almost a pleasant diversion. The Harrington jacket, Fred Perry top and pork pie hat are synonymous with this period to my mind and the portrait I take of the actor Mark McDonnell illustrates this nicely.

It is with a sense of great reluctance that I make the long trip to watch Gretna FC on a bitterly cold March night. I knew they were a club reborn, after the demise of the old Gretna in 2008, now wholly owned by their supporters. It is a long drive, but from the moment I near their wonderfully old-fashioned ground, I know it was worth it. I am a great fan of old football grounds. The out-of-town, prefabricated Ikea-style stadiums that so many clubs now have (including, sadly, my home town team of St Johnstone) have taken so much joy out of the game for me, but here in Gretna was a place out of time. Supporters were free to stand or sit as they wished. Free to wander or change ends at half-time. So many people spoke to me as I snapped away,

WEEK 19

Opposite

'Maggie Wall Burnt Here', Dunning, Perthshire

Mark McDonnell, Edinburgh

WEEK 20

Above

Football Supporter, Gretna

genuinely interested in what I was doing and keen to promote their club in any way they could. The simple act of trying to stay warm is made so much easier without being sandwiched together rigidly on plastic seats.

I came away from the game as in love with football as I had ever been. It may be a futile yearning for a long-gone way of watching the sport, but that night football was exactly as it should be – local people supporting their local club and having a belief that they, the fans, matter. These people were here not for the glamour or the glory, but for the belonging. This was as far from the soulless, corporate obscenity that top-flight football has now become and was truly all the better for it.

My previous trips to the most northerly and westerly points on the mainland have taken place in beautiful winter weather. Typically, the most southerly point on the Scottish mainland is shrouded in mist and swept with freezing needles of rain on the day I choose to visit. Photography-wise this is not a bad thing as extremes of weather often contribute to good strong images. It is me who suffers, as I pick my way down a treacherous coastal trail to the outcrop of rock that is the most southerly point in Scotland. The rain lashes

down and the wind whips the tough sea grass on either side of the path. Before long I make it to the bottom, where not unexpectedly another foghorn lurks.

I wander round the foghorn that lies just above the southernmost point. I am prepared this time and I have brought a little sound recorder to see if I can capture the baleful noise of the wind as it reverberates inside the trumpet cone of the foghorn. This time, though, the wind is too strong, and although the sound can be heard, the recording is useless as my recorder is battered by the wind. My album of ambient foghorn music will have to wait.

The weather finally clears, brightening a little, and I scramble back up to the top of the cliffs. On the seaward side of the lighthouse is a walled garden that falls away toward the ocean and I photograph the gate that leads into it. The gate points roughly SSW and if my calculations are correct, if you were to walk through this gate and carry on in a straight line you would not make landfall again until you reached the Antarctic Peninsula, 650 miles south of the tip of South America.

On my way home I stop to photograph the beach at New England Bay, where the waves are forming strange shapes on the wet sands, before packing up and heading north toward home.

Four months on from my last visit and I find myself once more in North Berwick. I am now in week 22 of my project and it would be fair to say it is taking up a lot of my time. Sometimes I make special journeys, and sometimes I photograph the places where I am going to be anyway. Today, I have an assignment for a magazine in the town, so I use my time wisely and combine work with pleasure. Or am I now combining work with more work?

It is a cold day with diamond-hard light. The schools are on

WEEK 21

Opposite
Most Southerly point, Mull of Galloway

Mull of Galloway

New England Bay, Dumfries and Galloway

Above
The foghorn at Mull of Galloway

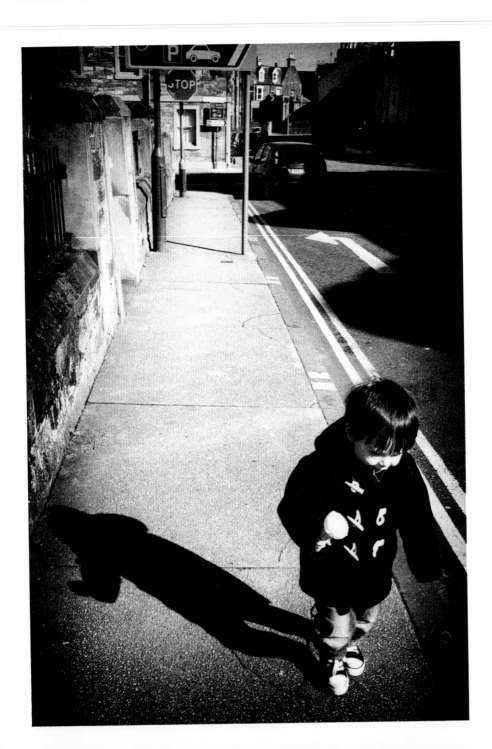

some form of holiday and there are lots of children around taking advantage of the sunlight. At the seafront an ice cream van is doing a brisk trade, despite the fact that I could probably warm my hands on one of his ice cream cones.

I have been toying with an idea to photograph Scotland's seaside towns in the off-season and I wonder if I should start here. Because the sun is out, though, it just doesn't feel like the off-season and I decide to put that series of images on hold till later in the year, when the summer is over and the resorts shut down for the winter. Cold though it is, spring really is not far away.

However, the icy sea breeze is affecting my desire to be outside and I am in a bit of a hurry to get home, so when I capture the photograph of a little boy in his duffle coat, scuttling down the road clutching his ice cream like an eternal reward, I know I have the image I am after and can happily move on.

April to May 2013

THE ROAD THAT curves and coils around the north shore of Loch Voil in the Trossachs is a narrow one. I have joined it at Balquhidder, where I stop briefly to visit the grave of Rob Roy, where he lies quiet now after a noisy life. He rests in the old churchyard that looks out over the valley below.

I am heading west along the loch, past partly hidden coves and inlets, and the occasional lonely tent pitched among the quiet trees by the water's edge. We have driven from Edinburgh, where I have just finished photographing the long-dead philanthropist and steel-man Andrew Carnegie at the National Library of Scotland. Not actually him, obviously, but a lookalike to help launch a book celebrating the centenary of the Carnegie UK Trust, which administers the large monetary sum that he bequeathed to good causes after his death.

It is Friday, and my girlfriend and I are heading to the hotel at Monachyle Mhor, between Loch Voil and Loch Doine. The seasons are turning and winter is in tentative retreat as March turns to April. All along this loch-side road, new life is bursting out as the warmth begins hesitantly to return.

The tranquility is suddenly broken by the noise of an engine heading down the loch towards us. Pulling over, I grab my camera just as a seaplane flashes past with a throaty roar. Within seconds it is airborne and away above the clouds. The long silence returns and everything is as it was before, as we head slowly on down the north shore road.

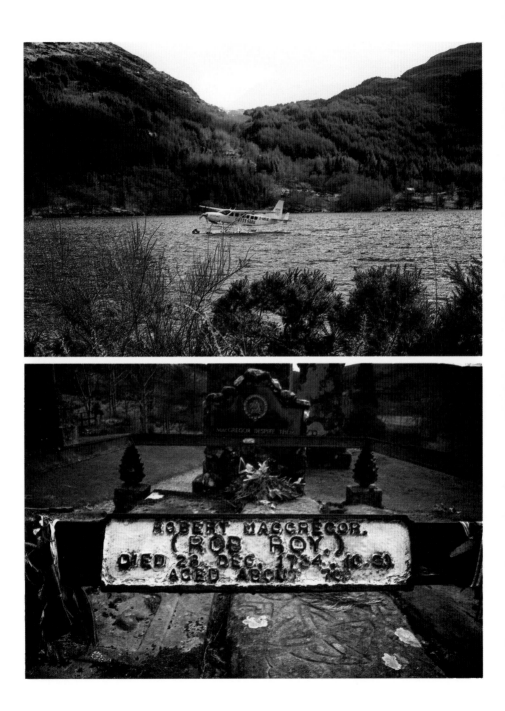

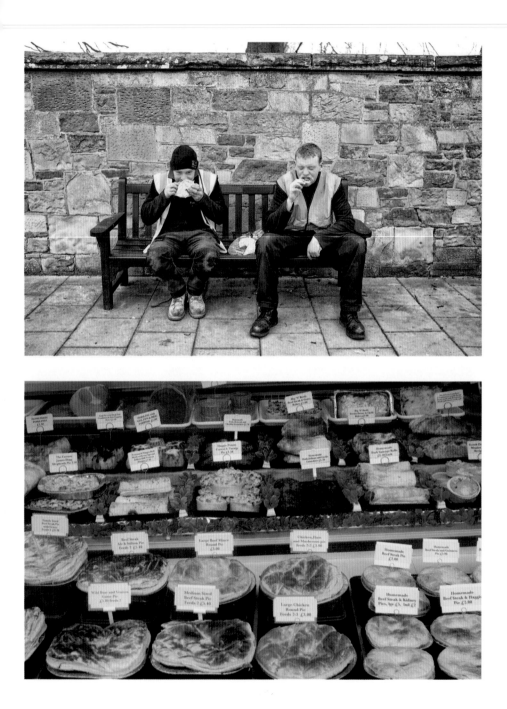

The Borders region of Scotland is still, inextricably, one of the most overlooked areas of the country. So often it is bypassed, as the A1 and the M74 direct those heading north and south past so fast that there is no time to discover its hidden delights.

Only recently have I begun to spend any real time here, which seems to make absolutely no sense whatsoever given that I live less than an hour's drive away in Edinburgh. I have travelled through the area many times on my way to England, though, but to me it seemed little more than somewhere on the way to somewhere else.

The road to Melrose, my destination, rises up as soon as I leave the outskirts of Edinburgh. It climbs into the Lammermuir Hills and reaches its highest point at Soutra, where ten years ago the huge wind farm was exotic enough to attract visitors just to look at it. Now commonplace, the wind turbines continue to turn, but are generally ignored by the countless cars that drive straight past them.

The road carries on down into the gentle, rolling landscape of the Borders and through the old market town of Lauder, where once the feet of Legionnaires traipsed as they headed north along the old Roman road, Dere Street, which was built before there was even a town here to pass through. On to Earlston, home of the 13th-century poet, prophet and friend of the elves, Thomas Rhymer. A few miles further and I take the turn for Melrose.

Melrose itself is a pretty little town, the centre of which is corralled between the ruins of Melrose Abbey to the east (where the heart of Robert the Bruce lies in a sealed lead casket), the River Tweed to the north, the rugby ground to the west, and the disused but lovingly preserved railway station to the south.

I spend quite a bit of time wandering the narrow streets, snapping away quite happily, and am about to move on when out of the corner of my eye I spot an old petrol pump up an alleyway leading to a goods yard. I have hit the mother lode. There is something about these old pumps that I am completely (and worryingly) in love with. To find one nowadays is rare – I last saw one ten years ago in a small village high on a windy plateau in southern France. I have even trawled the internet trying to locate some (I believe there are a couple somewhere in northern

WEEK 24
Workers eating
lunch, Melrose

Butcher shop,
Melrose

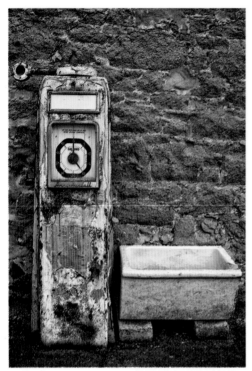

Scotland). And here one was, tucked away just off the main street in Melrose. For me this is Petrol Pump Pornography.

Deeper into the borderlands, in the Southern Upland hills, lies Hawick. Again, a town I have never visited before, but after spending a day here it is one that I now like immensely. It is a proper small town, part pretty, part functional with a real sense of a faded industrial past that is now being replaced with a renewed sense of dynamism.

It is lunchtime when I arrive and the centre of town is taken over by hundreds of schoolchildren. I am caught heading against the flow as I try foolishly to force my way upstream, like a particularly inefficient salmon. Eventually the flow subsides and I am able to move on, following the smaller of the town's two rivers, the Slitrig Water, as it heads away from the centre.

WEEK 24
Disused petrol
pump, Melrose

WEEK 25
Church, Hawick

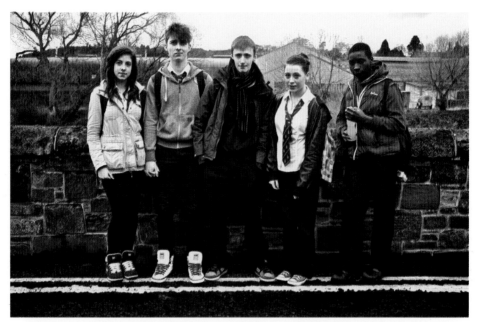

I photograph some of the school kids milling around this old mill town. They seem a bit nonplussed when I ask how they feel about being able to vote in the referendum. They are 16 and rightly have better things on their mind. The old industrial buildings are still here and huddle around the river that once provided all the power and water they could need. The old textile industry is gone now, for the most part, but the imposing structures that remain conspire to give Hawick a solidity that feels important.

WEEK 25
Schoolchildren, Hawick

An old industrial warehouse, Hawick

It is small towns like this that are the backbone of Scotland. The large cities as ever grab the glory, but it is here, in these places, where I believe the real essence of a country can be found. Coming from a small town myself, I have a special regard for them. Although, I left, so perhaps not that special...

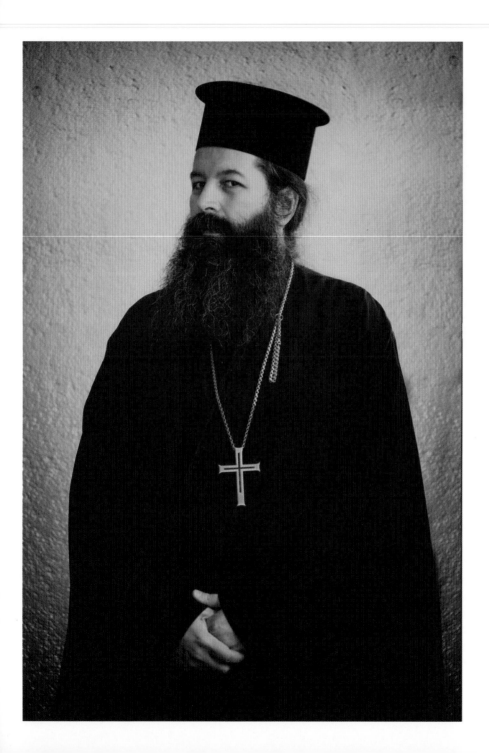

Sometimes each week's photography is planned out in advance and I know exactly what I'm aiming to do. On other occasions I like to see where I end up, and what looks interesting. It is this that leads me to Callander, where in a small café I spend more time than I should photographing the man on the next table, and not enough time on my coffee, which has cooled dramatically by the time I turn my attention to it.

The upside of being a professional photographer is that invariably I have my camera near to hand. I am at an event at the Glen Pavilion in Pittencrieff Park, Dunfermline, and I have just been told off by Princess Anne's security for walking in front of her as she marches through the park. Seemingly, this is a treasonable offence. As I retreat inside, I spot a man whom I instantly know I have to photograph. Archimandrite Raphael Pavouris of the Greek Orthodox Church of St Andrews in Edinburgh very kindly obliges. He, unlike the Princess Royal, has no problem with me walking in front of him so I take a quick series of images, the last of which catches him turning away with a last look back. It is far and away my favourite.

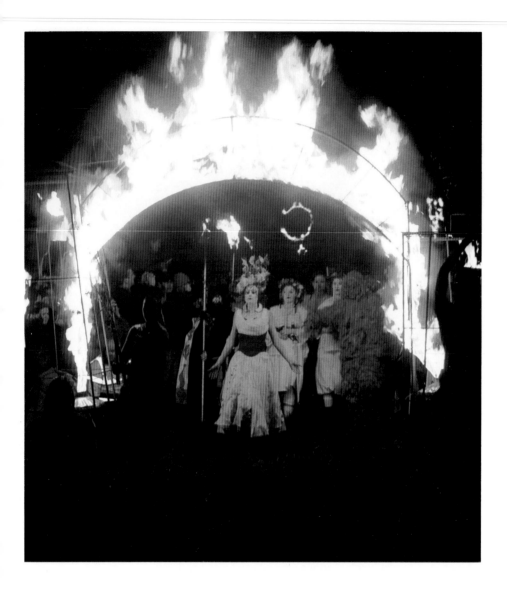

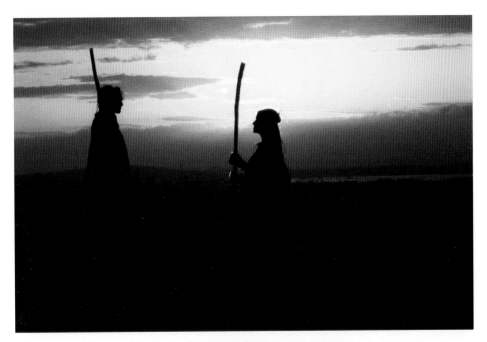

I already have the next few week's photography planned out, which is in some ways a relief. To go off on a whim and photograph what I see can be very exciting, but with deadlines constantly looming it can sometimes be a little too stressful. There is a time for structure and a time for freedom.

For millennia, the Celtic nations of the North had observed the festival of Beltane, or 'Bright Fire'. Slowly, as Christianity crept through the dark woods and rivers of wild Europe, the old gods stepped aside in favour of the new. They lingered on at the edges of the Continent in a more symbolic form and in Scotland the last public Beltane Fires would, by the mid to late 19th century, flicker and die.

As is often the way, what once was will one day be again, and in 1988 the Beltane fire came to life once more, on Calton Hill in Edinburgh. This was a small gathering of a handful of performers watched by no more than 100 spectators. As the years have passed the festival has grown and now hundreds of performers tell the Beltane story to thousands of spectators.

What has not changed is the central precept of Beltane – that

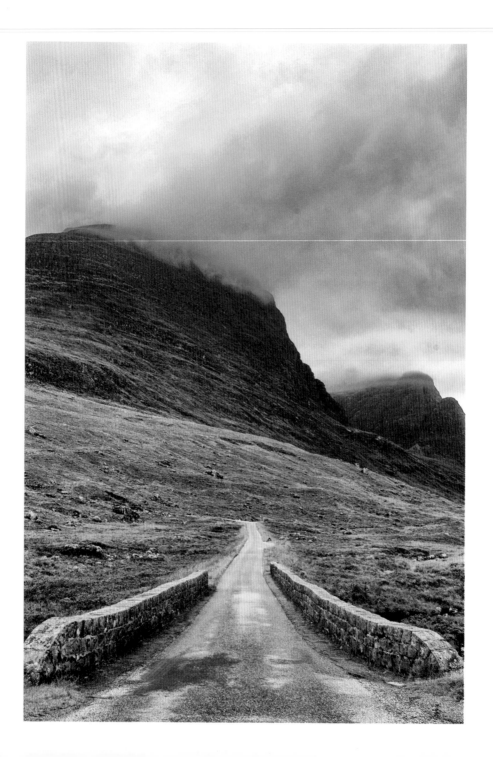

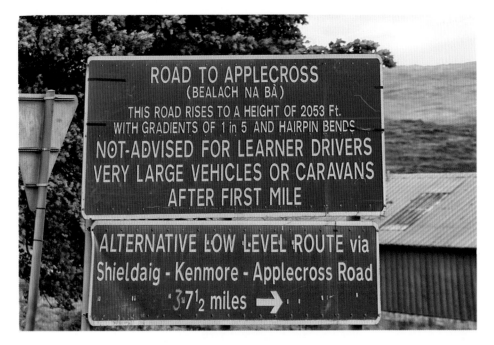

ROAD TO APPLECROSS
(BEALACH NA BÀ)
THIS ROAD RISES TO A HEIGHT OF 2053 Ft.
WITH GRADIENTS OF 1 in 5 AND HAIRPIN BENDS
NOT-ADVISED FOR LEARNER DRIVERS
VERY LARGE VEHICLES OR CARAVANS
AFTER FIRST MILE

ALTERNATIVE LOW LEVEL ROUTE via
Shieldaig - Kenmore - Applecross Road
37½ miles →

WEEK 29
Bealach na Bà: the
road to Applecross

Road sign at
Bealach na Bà

of rebirth and the welcoming of the summer after the long, hard struggle of winter. The lighting of the Beltane fires on 1 May would welcome the growing power of the sun and celebrate a sense of renewal and cleansing. This is symbolised by the procession of the May Queen and the death and rebirth of the Green Man. This year's Beltane takes place on a beautiful but chill evening on 30 April, the eve of summer, and as ever the event is a riot of colour and fire. As the sun sinks below the horizon, it truly feels as though the dark of winter has been vanquished, replaced by the soft warmth of summer. I wake up the next morning, and I realise it hasn't.

Standing at the very beginning of the old drovers' route which leads to Bealach na Bà (The Pass of the Cattle) is always a little nerve-wracking. This is the notorious road that hairpins terrifyingly over the mountains to Applecross, in Wester Ross. The road is more reminiscent of those found in the Swiss Alps as it switchbacks wildly over the peninsula before descending, thankfully more gently, into the tiny community of Applecross.

Until the late 20th century, this was the only route in or out of the village, and was completely impassable in winter weather. I first drove this road a few years ago in an old 1970s Volkswagen Type 2 campervan (now sadly sold) with a very dodgy clutch – there are no photos from the ascent as my hands were glued, white-knuckled, to the steering wheel. With the accelerator pedal pressed to the floor, I crawled up the slope, praying nothing was coming down because if I had stopped I would never have started again – not in an upwards motion, at any rate.

Today, even in my old Citroen, the ascent is much less frantic. The reward for the drive is the stunning views out over the sea to the Cuillin of Skye in the distance and the subsequent descent into Applecross, one of the loveliest and most remote villages in Scotland.

When I come to places like Applecross I know I have done the right thing in starting this project, this attempt to capture the soul of Scotland. I am slowly realising that there is no one country that can call itself Scotland. There are, I am beginning to suspect, an infinite number of Scotlands. It is the land, it is the people. It is the city

and the forest, the road and the river.
I am beginning to understand that it is
the interplay between all these things
that defines a country. I have a long,
long way to go, but for the first time, as
I stand looking out over the ocean with
the Applecross Inn behind me, I feel I
am beginning to get the measure of the
country and it only serves to make
Scotland seem bigger and more
complex than I had ever imagined.

Like so many, I have been a football
fan since I was a child. The fact that I'm
from Perth obviously means St Johnstone
are my team. Despite this, and alongside
a lifelong series of disappointments
from the Scotland national team, I am
almost as enthusiastic as I was when I
was 11 (not quite, though, as just holding
a Kenny Dalglish Panini sticker back
then would make me hyperventilate).

It is the lower leagues, the smaller
teams, the older grounds that interest
me the most. In some ways what happens on the pitch is
secondary to the events that take place before and after the game.
The ceremony of football and the architecture of the game are
what attract me to it. The thrill I feel walking to the ground on a
freezing night, when the first glimpse of the floodlights quickens
the blood, is as strong now as it ever was.

These images from Perth, Aberdeen and Cowdenbeath show
the periphery of the game, which to me is what makes it so special.
From the ramshackle club shop at Station Park in Cowdenbeath
(easily one of my favourite grounds) through the pies of Perth
(tasty) to the turnstiles of Aberdeen, this is a selection of what
matters to me about football, and what has kept my interest for all
the years since I first stood on a floodlit terrace watching St
Johnstone battle it out against Dundee, which we won 3–2.

WEEK 30

Opposite

A tasty pie at the
St Johnstone v.
Dundee match,
McDiarmid Park,
Perth

Station Park, home
to Cowdenbeath FC

McDiarmid Park,
home to
St Johnstone FC

Above

Pittodrie, home to
Aberdeen FC

June to July 2013

SIX MONTHS AGO, on my way to Ardnamurchan Point, I was in a conversation with an elderly woman about my project. I explained why I was heading to the westerly point and why at some point I would be heading to Peterhead, the easternmost point on the mainland. She, it turned out, was from Peterhead and filled me with terrible tales of the cold and ice that seemed, to her, to eternally grip this winter seaport. 'The Blue Toon,' she called it. Blue for cold. Blue for ice.

And now, half a year on, here I was standing on Keith Inch, Peterhead, looking out from the easterly point. She was right about 'The Blue Toon', although very, very wrong about the temperature. Here is a cobalt blue sky above an aquamarine ocean on a perfect, warm day in late May. I am almost disappointed that her warnings of Arctic doom have not come to pass. Almost.

I realised some time ago that the most easterly point on the mainland would not have the same natural beauty as Dunnet Head in the north, Ardnamurchan in the west or the Mull of Galloway to the south. Keith Inch was once an island off Peterhead but now forms part of the town's harbour. I knew it would be industrial and the research I had carried out beforehand had painted me a rather uninspiring picture of the area. I was expecting a difficult day's photography. Yet how easily we can be fooled.

This most easterly point stands on private property and I was unsure if I would even be allowed access. However, I know from experience how the security guard, caretaker or janitor can be a photographer's best friend. Get them onside and you can go anywhere, and happily, the same applied here. The guard clearly thought I was somewhat deranged or, sadly, that I was definitely no spy.

The eastern edge of Keith Ness has its own stark and bleak beauty and the moment I saw the huge, rusting oilrig anchors on the coastline, I knew I was going to get plenty of images. These huge anchors, twice my size, are from the oilrigs that dominate

WEEK 31
Oilrig anchors at Keith Ness, Peterhead

Two discarded trailers by a corrugated iron wall, Keith Ness, Peterhead

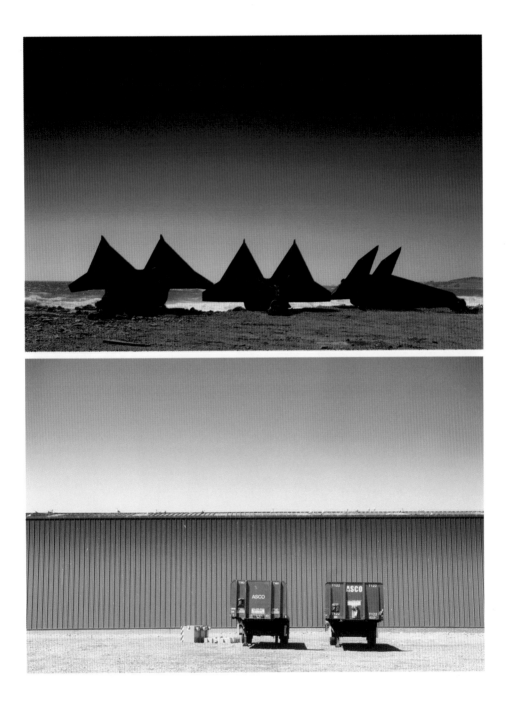

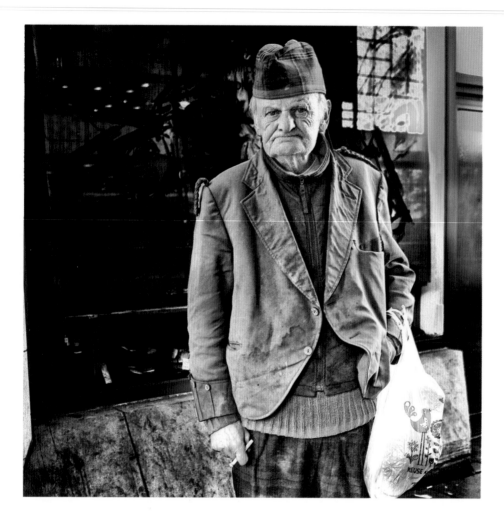

this area of the North Sea, and to see them quietly rusting in the
heat was an impressive sight. As I wandered around there were so
many interesting objects and sights that my task was rendered
easy. Industrial landscapes can have a beauty every bit as
photogenic as rural landscapes – when it comes to photography
I would much rather be in a world of warehouses and wharves
than on the side of a mountain or in the depths of a forest. I love
nature, and I love the wild and empty places, yet I find them far

less interesting to photograph than a couple of discarded trailers in front of a corrugated iron wall.

As I sit on this first truly warm day of the year, staring east over the North Sea towards Norway and beyond, with my back warmed by the heat from the hulking anchor I am leaning against, I think: 'Peterhead is blue and there's nothing I can do'.

People are what make a country. I am at my happiest when I am photographing them. The whole process of talking to people and getting to know them a little in order to take a good portrait is a great pleasure. Sometimes I will arrange a portrait in advance, such as the photo of Pauline, a black belt in Tae Kwon Do, and other times I will grab them in the street, or in the case of the image above, they will grab me and demand to be photographed.

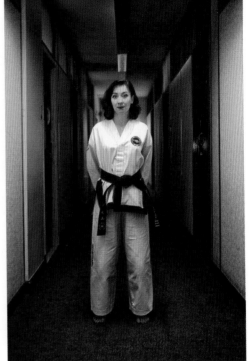

WEEK 32
Pauline, black belt in Tae Kwon Do, Edinburgh

There are many factors involved in making a great portrait, of which the actual photograph is probably the least important. I have seen and taken many images where the photograph is technically far from perfect and yet the spirit and the character of the subject shines through regardless. Sometimes it works when a person is relaxed, sometimes the best portraits are when the whole session feels a bit on edge. Some of the best portraits I have seen were taken when the subject was not entirely happy. As a photographer, you never know just what you are going to get. What's important, though, is what is in front of the camera and not what is behind it.

One of the greatest pleasures I am finding in working on this book is the chance to meet, talk to, and photograph people from all over the country. Every person I meet, from the richest to the poorest, is as important and as vital in the story of the nation as the next.

I have now reached the one-third point of this 100 Weeks of

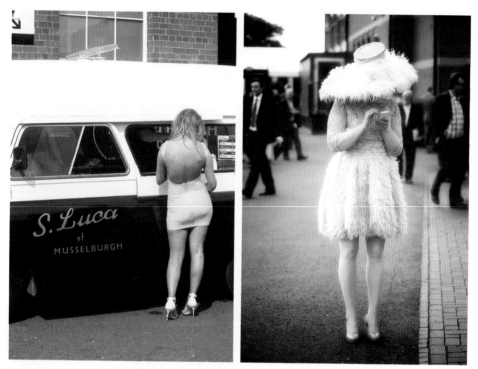

Scotland project and as a reward to myself on a warm and sunny day in early summer, I decide a trip to the races might very well be in order. Musselburgh Races, a few miles along the coast, is on today and to make matters all the more interesting, it is Ladies Day. I have only once before been to the horseracing, when I was a photography student shooting for my Sports Photography module. I came home that day with a huge amount of galloping horses. Today I am concentrating on a much more fascinating subject – the spectators, and mostly, what they will be wearing.

Even your average run-of-the-mill race day is, I suspect, about far more than just the horseracing. Events such as Ladies Day ensure that, if anything, the horses only take a minor role in the whole day's proceedings.

I arrive at the gates to the old racecourse in weather that could not be more tranquil. A huge crowd has turned out for the meeting, and it is clear that what they are wearing is of the utmost importance today. From sharp-suited men to the frankly

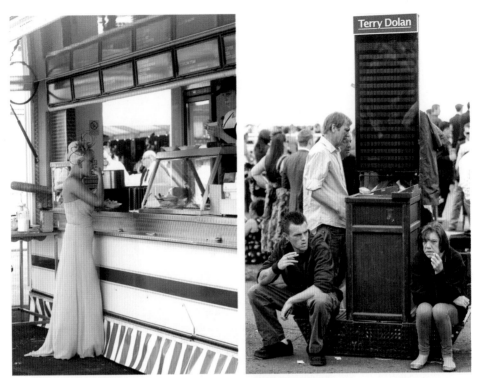

wonderful and exotic looks of the ladies, it is a day of delightful contrasts: from ballgown-clad girls buying chips from fast food stalls to bored, slightly menacing looking bookies sitting in the midst of a sea of taffeta, fake tan and high heels.

WEEK 33
Scenes from
Ladies Day at
Musselburgh
Racecourse

It is like a cross between the best wedding ever and a football match. I take enough images within the first ten minutes to give me an entire book's worth of photographs. The atmosphere is friendly, and the champagne, wine and lager is flowing.

Picnics are taking place alongside the track and fashion shows are happening in the marquees that stretch away from the main stands. Some of the clothes are elegant and understated; some are not. Nobody minds, though – the sun is shining and even the last race won't signal an end to the proceedings.

I realise as I leave that I never got near placing a bet or actually watching any of the races – the riot of colour and life that happens on Ladies Day is more than enough entertainment, and the horses

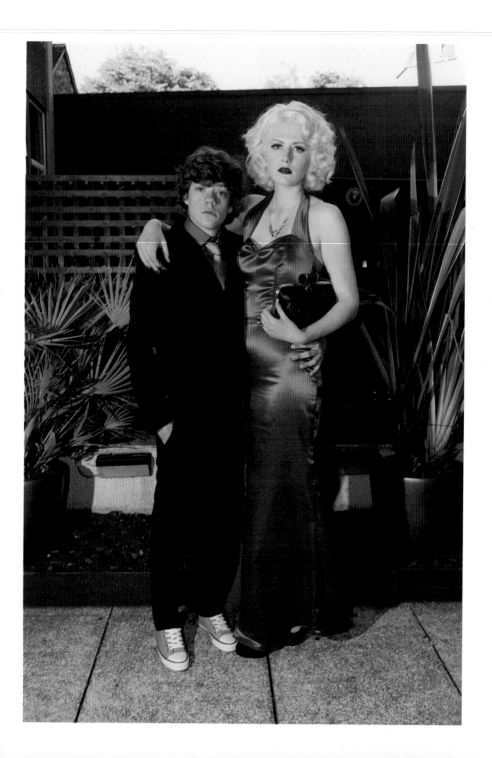

just couldn't get a look in. I head home after a fascinating day with a camera bursting with images, a stiletto wound on my foot and a can of Pimms stuffed into my pocket.

When I left school there was no such thing as a School Prom. Back then, we just drifted off slowly, unheralded and unnoticed, into the unwelcoming bosom of Thatcher's Britain. Some school friends were kept, some lost, some thankfully never seen again. Now, though, where every single one of life's landmarks, no matter how small or insignificant, must be celebrated, the School Prom is big business. Hotels, clothes shops, DJs all queue up to milk the proceeds from this latest of cash cows.

And yet, despite all this cynicism from me, and hard-nosed profit from everyone else, there remains something hopeful and touching about these events. The past is celebrated, but it is the future that is important now, waiting shining and tempting in the wings. For the school-leavers themselves it is a massive event – dresses, suits and hairstyles are all chosen, discarded and re-chosen in the run-up to the event. Everything is planned with military-grade precision and nothing, and I mean nothing, is left to chance.

It is a real pleasure to see these young people, teetering on high heels and the edge of adulthood, say their goodbyes to not just their fellow school friends but also to the life they have known until this point. They get such bad press from the *Daily Mail* school of

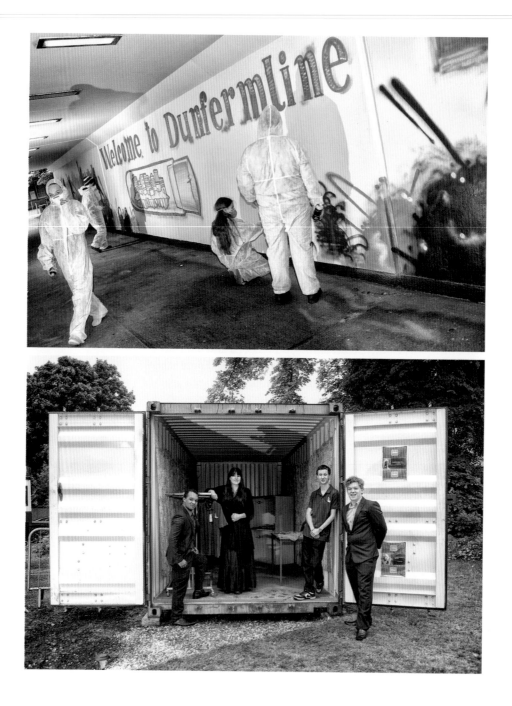

journalism, in which teenagers are depicted as little more than rioting, feral beasts. Yet looking at these kids, I have a sneaking suspicion that they will be alright. More than that: they may just make less of a mess of things than previous generations have done.

I am always am happy to visit the old Scottish Capital city of Dunfermlin' Toun. Its location on a hilltop overlooking the River Forth is impressive, and it is steeped in history.

Like a huge number of towns these days, its retail centre has seen better times, though. The relentless march of huge, identical, out-of-town shopping centres is having its inevitable effect on the High Street and, as in so many other places, there is a depressing amount of vacant premises in the town centre. To me, these empty and shabby premises seem to suck the life out of a place.

However, thanks to the Carnegie Trust, Dunfermline is beginning to fight back and is hoping to revitalise its centre. 'TestTown' is a new competition for young people throughout the UK aged between 16 and 25 to put forward their own ground-breaking ideas to redesign the future UK high street. The top 11 finalist teams with the most exciting ideas have relocated to Dunfermline and for three days will take over vacant town centre space, to trade with real consumers. The winners – those who do the best job of turning their ideas into reality – will walk away with £10,000 to take their idea to market for real.

It is a fantastic idea, and as I walk round the 11 pop-up shops the imagination and positivity of the each of the winning teams is infectious. The ideas range from a soup kitchen championing local produce, vintage clothes shops that will kit you out there and then for a night out, and a range of clothing that links its handmade garments to music from its own record label.

There is nothing of the hard-nosed

cynicism of *The Apprentice* about this – it is young people coming up with genuinely workable concepts who, when given but the smallest of chances, can show the incredible range of talent and dynamism they possess. Landlords and local councils take note: if ideas like this exist there is no reason, ever, to have retail space lying empty in a town centre.

Tucked away in the corner of a picturesque Perthshire churchyard, behind an 18th-century wall built for its protection, stands an ancient and gnarled tree. Estimated to be over 5,000 years old, the Fortingall Yew is widely recognised as the oldest living tree in Europe, and possibly anywhere outside North America. It took root in this land centuries before the Pyramids were constructed and was approaching its first millennia when the bluestones of Stonehenge were being dragged across Salisbury Plain.

When the tree was some 3,000 years old, did a small boy from the nearby Roman camp play and climb in its ancient branches? Legend has it that this boy was Pontius Pilate. The story goes that in 10BC his father, a Roman envoy for Caesar Augustus, was visiting the local king Metallanus in order to persuade him to pay tribute to Rome. While here he fell under the spell of a local girl, who bore him a son. The boy was given his father's name and taken back to Rome, where in time he grew up and was made a free man and given a pilateus, the felt cap worn by a freed slave. He would then go on to become one of the most famous, or infamous, characters in history.

A few miles away, where the River Tay winds its way past Dunkeld on its eastern shore and Birnam on its western, stands another tree of legend: The Birnam Oak. This impressive and huge old tree is a relic from the ancient medieval Birnam Wood, immortalised by Shakespeare in his play Macbeth.

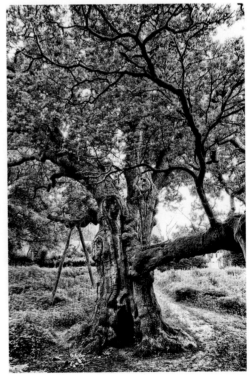

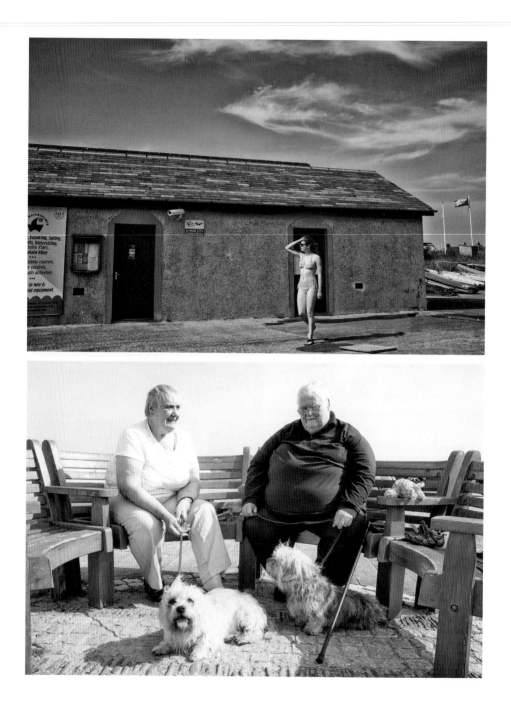

Tradition has it that Shakespeare was inspired to write the play after visiting the area as an actor, and indeed, records show that a group of English strolling players were permitted to perform in Perth in 1589. Sadly, though, none of their names were listed.

A few miles north of Perth, just outside the village of Meikleour stands the Meikleour Beech Hedge, the tallest hedge anywhere on the planet. It is 580 yards long and averages 100 yards in height. It was laid out in the spring of 1745 to denote a boundary by Jean Mercer of Meikleour and her husband Robert Murray Nairne, who within a few short weeks would be killed fighting the Hanoverian troops at Culloden.

I am now 37 weeks into my project and the country is reeling under the twin shocks of scorching weather and a Scot, Andy Murray, winning Wimbledon.

Despite the heat outside, several people are in The Ship Inn watching the momentous match. I am in Elie, Fife, and the Men's Singles final is on a little TV in the bar and is also showing outside, thanks to a carefully positioned TV that is visible from the beer garden. I try to watch it, but my nerves get the better of me, so every now and again I venture out into the sun with my camera.

Elie is, along with Pittenweem, Anstruther and Crail, one of
the gems of the East Neuk of Fife, a part of Scotland I have visited
many times and keep coming back to. These small fishing villages
are dotted along the north shore of the Forth Estuary: where once
fishing was the main industry, this has now been complimented,
if not altogether replaced, by tourism.

I wander down to the harbour and photograph girls in bikinis
(is this really Scotland?) and a couple taking a rest from the heat
with their dogs. Then, back to the pub in time to witness
something none of us ever thought we would ever see, as Andy
Murray sees off Novak Djokovic to become the first Scot to win
Wimbledon since Harold Mahoney in 1896.

I don't think I'm alone in being a fan of old red telephone
boxes. It's always a pleasure when I stumble across them in
unlikely or out-of-the-way places. And to find one that is still in
working order is even more unusual and exciting. Two iconic

images spring to mind when I see red telephone boxes: the album cover of David Bowie's *The Rise and Fall of Ziggy Stardust and the Spiders from Mars* and the memorable scenes in the film *Local Hero*, where the phone box is crucial to the imagery of the film.

It was getting dark when I found this phone box at Kingshouse, midway between the northern end of Loch Lubnaig and the western point of Loch Earn. In my travels over the past few months I have noticed, though, that the red phone box is still alive and well across the country. It may have retreated from the towns and cities, but it is still often found in rural areas. Virtually every small village still has at least one red phone box. Most are used as they were intended, but others have been converted into things as diverse as unofficial community libraries and art installations. There is even a scheme running to place defibrillators in rural communities, and these old phone boxes would provide the perfect location.

Back in Edinburgh, I am out walking when I spot a little street sale. These pop up every so often and I always try to buy something if I can. Some Yes stickers were on sale as well as some No

WEEK 39
Julie Wilson-
Nimmo

stickers. When I make my choice, the other stickers were surreptitiously covered up. These children will go a long way in retail with such attention to detail and care for the customer!

I have begun to notice the referendum more and more over the past few weeks. Since the date, 18 September 2014, was announced a few months back by Alex Salmond and Nicola Sturgeon, things have definitely moved up a gear. The announcement placed the referendum in week 99 of this project, and although I had hoped to finish with the vote, this now gives me the opportunity to have a week in which to look at the aftermath of the event. It is over a year away and it is already an inescapable part of Scottish life, from the bus stop to the Debating Chamber of the Scottish Parliament. Scotland is alive with possibilities.

As I mentioned previously, sometimes portraits can take a lot of planning and sometimes they just happen very naturally. Both approaches are equally valid and I wouldn't necessarily say one approach is better than another. I have spent the week photographing

actors both for this project and also for another spin-off project I am carrying out called 'Magnetic North'

Television, like it or not, always plays a huge role in the cultural make-up of a country and its people, and Scotland is no exception. From the early depictions of a couthy Scotland in the likes of *Dr Finlay's Casebook* and *The White Heather Club*, through the gritty 1970s work of Peter McDougall, and right up to more recent times when programmes such as *Taggart*, *Still Game* and *Hamish Macbeth* have proven to be hugely successful. Television is often a mirror reflecting how a nation sees itself.

Of the three portraits of well-known Scottish TV stars, two are reasonably spontaneous and the other is planned. The image of Julie Wilson-Nimmo, well-known for her work in theatre and TV, is in the former category. We wander around for a while on the waste ground that borders my studio (always good for locations), looking for a decent background before finding a rusting cargo container, then everything falls into place. The contrasts of colour in this image work well, I think, and I am very pleased with how it turned out.

WEEK 39
Iain Robertson

The portrait of Colin McCredie is a fairly obvious nod to his role as DC Fraser in STV's long-running crime drama *Taggart* and I have planned it in advance. It is always pleasing when the image that you have in your head is actually the one that you end up with when the shoot is done. Many times this is not the case, as something will often get in the way of the shot and in this case it was almost the sun that spoiled things. As Colin was looking straight into it, it was difficult for him not to squint. His eyesight is now irreparably damaged, but at least I got the shot...

And then we come to actor Iain Robertson, who is renowned

for many roles, including *Sea of Souls* and his BAFTA-winning appearance in the film *Small Faces*. I took his portrait during a break from rehearsals and the shoes, to the best of my knowledge, aren't part of his daily look, although as far as I am concerned anyone who has been in *Grange Hill* can wear whatever they like, whenever they like. He was a great subject and made my job so much easier.

WEEK 39
Colin McCredie

August to September 2013

ARRAN IS OFTEN described as Scotland in miniature. The southern part of the island, is low-lying with rolling, arable fields, the central part is the most populous, while the north is mountainous and wild. I feel very lucky to be here and yet extremely unlucky to only be here for a few hours. I have had a photo job on the island and now I do not have much time before the ferry back over to the mainland. There is only one thing for it – I jump into my car and drive as far as I can before my time here runs out and I have to head back to the ferry port. I head north from Brodick along the coastal road that heads to the rugged north of Arran. The villages of Corrie and Sannox slip past, quiet in the summer evening, and before long I am following the long stretch to Lochranza. The sky suddenly explodes into colour as the sun finds a gap in the clouds and reveals what looks like a small

WEEK 40
The sky explodes with colour on the road to Lochranza, Arran

portion of heaven. The brake pads squeal in frustration as I pull over and manage to capture the glory ahead.

My time on the island has run out, but the brief glimpse I've had of it makes me feel sure that I will return for a longer visit before this project is complete.

Back on the mainland, I head up to Pitlochry, which is one of my favourite places in Scotland. I came here many times as child and although now it is now quite touristy, there is still enough charm and originality to the place to allow its history as a picturesque Highland town to shine through.

It is an unseen and persistent hand that forces me to visit once again the salmon ladder, where on numerous occasions as a child I would stand fingering the glass in the vain hope of seeing the promised salmon that swam through, past the dam, and on to the upper reaches of the River Tummel. How many sticks floated by that, in my childish imagination, were glittering salmon would be beyond count. I have my dad with me today and we walk over the hydroelectric dam to the town itself to visit the cottage at Lagreach where his mother was born, and where long before the dam was

built he played as a boy during the Second World War. The cottage is now surrounded by modern houses, which crowd and dominate it, so I decide not to photograph it. As my dad says, it is not the place it once was. There is only one thing for it – we walk back into the town and buy some fish and chips. Those, happily, are as good as they ever were.

It would be a crime not to cover the largest arts festival on the planet, which happens on my doorstep . When I first came to Edinburgh after university, I couldn't believe just how vibrant the city became, how it transformed itself effortlessly for a month in August. I was also very impressed at how ridiculously late the pubs stayed open.

What I also noticed, however, is that if you don't live or work in the centre of town, it can also completely pass you by, whilst if you do (and this is a common complaint), it can sometimes prove to be a bit 'annoying'. There have been times when I have been rushing between jobs and my progress has been hampered by majestic herds of tourists sweeping across the plains of the Old Town. Surely a small price to pay for four weeks of delight, though?

WEEK 40
The hydroelectric dam, Pitlochry

Knowing how busy the Royal Mile can be with performers desperately dispatching flyers, I start photographing early. I soon find myself hopelessly adrift on a rising tide of painted faces and multi-coloured Dr Marten boots. I was hoping to get a mix of the local and the exotic and as many candid shots as possible. Easier said than done, though – if you point a camera at a performer, they tend to perform.

As always, the Royal Mile during the Festival is hugely entertaining. Yet, as I walk home through a wilderness of flyers gone to ground, I ask myself the same old question – just where do these street performers get changed? I never see them in the

outskirts of Edinburgh or on buses. They appear magically in the city centre and then quietly (noisily) melt away into the closes and alleyways of old Edinburgh, never to be seen again. Until tomorrow.

When I was a child, airports seemed impossibly remote and glamorous, so much so that they didn't even encroach on my early imaginings of adventure and exotic locations. Railway stations did, however. These were places that I actually walked past in normal life, or rather was driven past in the back seat of my dad's powder blue Vauxhall Cavalier. I remember clearly the first time I went inside Perth railway station. The frontage was so small, nondescript and underwhelming (it still is) that I imagined the station would be tiny. Little did I expect the vast, sprawling complex of tracks and platforms straight out of a 1940s film.

Ever since then I have loved railway stations. There is a romance to them that is missing from the great sterile people-processors that airports have become. I have been planning to photograph railway stations for some time and I decide to avoid

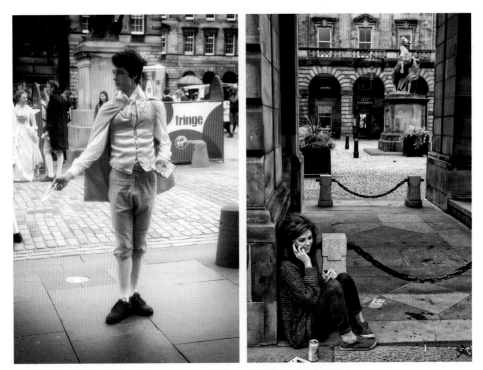

the larger metropolitan ones in favour of the smaller stations that have changed little over the years, those that still retain an aura of another age.

Rannoch railway station is remarkable. It is set amidst the remote vastness of Rannoch moor, one of the true remaining wildernesses in the British Isles. The nearest settlement of any size, Kinloch Rannoch, is 20 miles away over the moor and along Loch Rannoch. Here is a train stop that is testament to the opening up of the Scottish Highlands to the guns and gundogs of the rich and powerful of the Victorian era. I photograph the view from the end of the platform, looking due north to great hunting estates and mountains of the Central Highlands and beyond.

Night-time in Cowdenbeath railway

WEEK 42
Rannoch railway station, Rannoch Moor

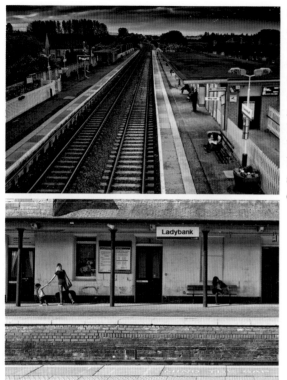

station evokes the feeling of WH Auden's *Night Mail*, knowing that standing here on this platform in central Fife, in the gathering dark, I can step through a doorway and be transported anywhere in Britain, Europe and beyond. Paul Theroux begins his book *The Old Patagonian Express* by boarding a commuter train in the suburbs of Boston. One of the early morning commuters asks him where he is headed: 'Tierra Del Fueg,' he replies. This is the enduring magic of railways.

Ladybank, also in Fife, is a fine example of the rural train station, and instead of falling into disrepair, it has been put to alternative uses. Although still a mainline station, many of the old buildings are now used as artists' studios and exhibition spaces. It ensures that the station doesn't slowly crumble through lack of maintenance and neglect.

Melrose railway station, unused since 1969, is to be found quiet in the rain on the day I visit. The tracks are gone but everything else remains. If ever there was a station waiting for a train then this would be it. Perhaps the new Borders Railway, which terminates only a couple of miles away will one day bring

WEEK 42
Cowdenbeath railway station

Ladybank railway station

The disused Melrose railway station

trains here once more. Until then, this old station will continue its long slumber.

As I have already mentioned, television has a major part to play in the culture of a nation. It can define it, energise it and represent it, both positively and negatively.

I realise that to most people outside Scotland, *River City* is not something they will be too aware of. But since first appearing on our screens in the autumn of 2002, and after the inevitable teething troubles that all soaps have to contend with, *River City* soon established itself as a favourite throughout the country. Like all soaps, it is not to everyone's tastes, but there is scarcely anyone who is not aware of its existence and who hasn't at least a vague idea of who some of the main characters in the show are.

I have travelled to the purpose-built set just outside Dumbarton to take publicity stills for a documentary on the programme. It is a warm day and the set is quiet, as filming has just finished for the summer. Wandering round the empty tenements of Glasgow, set

WEEK 43
Joyce Falconer as
River City's Róisín

Johnny Beattie as
River City's Malcolm

WEEK 43
Una McLean as
River City's Molly

here in the middle of an old whisky bond warehouse in Dunbartonshire, is a surreal experience. The attention to detail is impressive. Entryphone systems set in the red sandstone have the correct names on them. The postbox has a list of collection times and the subway station displays timetables for trains that will never run. It reminds me a little of Sunday afternoons when I was child, when the crushing silence that seemed to descend on the world seemed all the more bleak in the knowledge that there was school the next day.

The cast presently boasts two of Scotland's best-loved entertainers, Una McLean and Johnny Beattie, as well as a large and ever-changing cast of both up-and-coming and well-established actors. After the sad demise of *Taggart*, *River City* is the only long-running drama in Scotland and, as such, is an incredibly important employer of not only actors but also of crew and production staff.

What's more, with the character of Róisín (Joyce Falconer), who appeared in the show regularly in 2002 and returned briefly in 2009, *River City* boasted one of the finest soap characters

around, one that would not have been out of place in *Coronation Street* during its golden age in the '60s and '70s.

I head back to Edinburgh for my next assignment in the project. Since its inception in 1995, the Edinburgh Mela has grown in stature and importance each year and is now one of the main festivals in the city, and is possibly my favourite. The Mela, a Sanskrit word meaning 'gathering' or 'meeting', was originally located at Meadowbank Stadium before moving to Pilrig Park then Leith Links, where it is currently held.

The event is gloriously multi-cultural; it is a riot of colour, music and wonderful food. The food in itself, which ranges from North African to Asian and beyond (with the obligatory, slightly embarrassed-looking burger stall), would be reason enough to visit the Mela. Combine this with dozens of stalls selling a large range of objects and clothes, fantastic facilities for kids and a diverse and energetic cultural programme of music, dance and fashion, and you end up with one of the most vibrant and eclectic of all the festivals in the Festival city.

The second day of the two-day event starts of well-enough

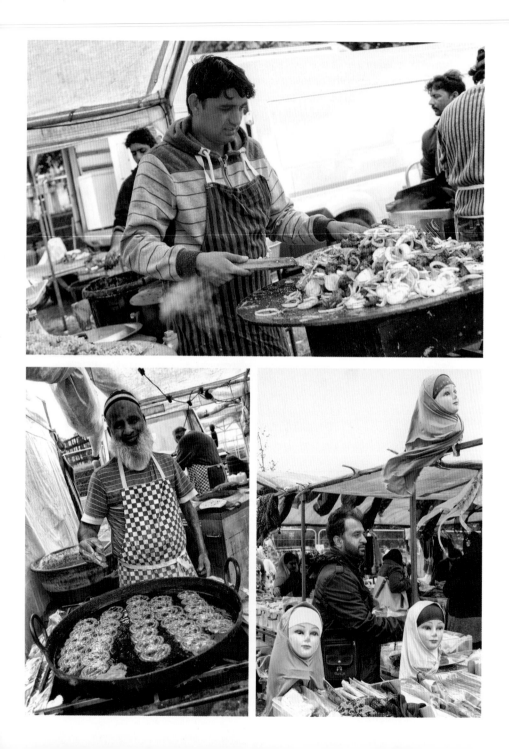

weather-wise, but due to some unseasonably strong winds, it begins to look like trouble may lie ahead as much of the festival takes place under canvas. As I wander around photographing the sights, the wind is beginning to take its toll and areas of the event are temporarily closed.

Sadly, as the day progresses, a decision is made to cut the event short. As the Mela had pulled off a wonderful coup in booking The Orb to climax the festival, this results in a lot of disappointed fans, including one very downcast and hungry photographer, as I had purposefully delayed my visit to the food area until after I had taken my photographs. I won't be making that mistake again.

Like most in Scotland, I first heard of New Lanark at school. Slumped and ensconced in a snorkel jacket, I would be present in body only as Mr Mackie droned on endlessly about linen, mills and working conditions in 18th-century Scotland. I was miles away, as usual, happily considering which particular girl I was unrequitedly in love with that day.

Now, years later, and visiting New Lanark for the first time, I am completely amazed by the place. If ever there was a reason to take schoolchildren on trips to understand history, then this is it. Even the approach is a complete surprise. As I drive through Lanark to this world heritage site, I assume I am roughly at sea level. I am not. The very steep drop into New Lanark is totally unexpected. And then the buildings. They look as though they were constructed yesterday. And then there's the setting. A deep gorge on a sylvan sweep of the River Clyde. Wonderful, and wholly unexpected.

It is impossible to be in New Lanark without wondering what it was like in 1786 when David Dale had the vision for a revolutionary shift in working practices. For all the advances and

WEEK 44
The Edinburgh Mela

WEEK 45
The historic cotton-mill building, New Lanark

The Clyde Walkway, New Lanark

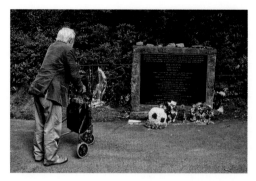

improved facilities for the workers, it would still have been a hard and exhausting place to work. I wonder what the orphan children recruited to work the looms would make of it now, as busloads of European tourists are ferried around the mills and wedding parties celebrate in the hotel.

I think of those long gone workers often as I walk around. It is a lovely late summer's day, but still the ghosts of those who lived here seemed to flit around at the corner of my eye. Is it because it looks as if they had just finished a shift and streamed up the hill to their newly built tenements? Who knows, but there is a strong sense of 'what has gone before' about New Lanark.

Leaving New Lanark behind, I head further west to photograph the memorial to Bill Shankly, the legendary former manager of Liverpool FC, as today marks the 100th anniversary of his birth in the now ghost village of Glenbuck. It is a testament to what he achieved that many take the trip north from Liverpool to pay their respects.

I went in search of what was left of Glenbuck, but sadly discovered that nothing remains – nothing but the memorial to Shankly, that is. I meet an old fisherman at Glenbuck Loch who shows me photographs of what the village once was: a hard Ayrshire mining town, yet one set in beautiful surroundings. 'The railway passed over the middle of the loch on such a low embankment that when the mist was on the water it looked as though the trains were floating on the loch,' he told me. 'All gone now though. The village, the railway, the people. The bloody lot.' I leave him with his memories as, in the fading light, he casts off once more.

It is cold, it is raining, and even my dog looks miserable as I find myself standing a few miles over the border in a deserted and muddy Northumberland field. Flodden field. On this day, 9 September 1513, half a millennia ago, this field was far from deserted. It was littered with the mutilated bodies of many thousands of men, most of them Scottish. I stand in the exact

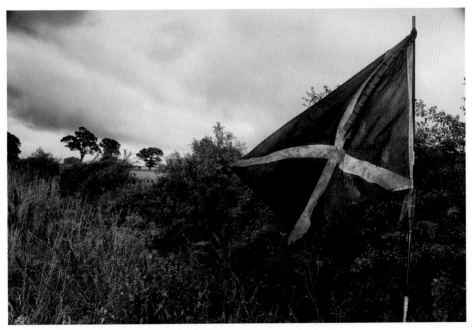

centre of where the Battle of Flodden took place. Centuries quiet now, but still there is a vague feeling that *something happened* in this place. There were people here to commemorate the battle earlier but they have gone and now only the crows and myself remain.

To me, as a child, Flodden was mentioned in the same hushed tones as the Darien disaster, or the 1978 World Cup in Argentina. It seemed to be one of those 'national tragedies' that have to be endured but were really best not mentioned. I knew very little about the Battle of Flodden, other than that it was a very dark event in a country with a history of many other dark events.

Very little, it seems, has changed in the landscape. The steep slope, which rises to the south and where, with ill-judged enthusiasm, the Scottish pikemen came thudding down to meet both their fate and a murderous English billhook, is as it was. The boggy ground where the two armies thundered together may have been drained but, other than that, most of the geography is the same. A couple of forlorn flags – a muddy Saltire and a more resplendent St George's Cross – hang limply in the region where most of the killing would have taken place.

WEEK 46
The Battle of
Flodden
Monument,
Flodden Field,
Northumberland

It is an eerie place in the fading light. Do the events of long ago linger in the physical world and echo down the years? Today, standing here, it is easy to believe they do.

A king once died a few feet away from where I stand – King James IV of Scotland, who now holds the dubious honour of being the last king to die in battle in Great Britain, an honour he will probably retain for quite some time to come. He needn't have died, as he needn't even have been here. The Scots only invaded England to honour the Auld Alliance with France, who were (as usual) at war with the English. The serpentine mess of treaties and alliances that seemed to cause more fighting than it ever helped avoid led the two armies to this place, on a September day, 500 years ago.

The Scots suffered a heavy defeat, with her King and many of her nobles killed. It is not too controversial to say that this defeat helped lead the way to the Union of Crowns, and then eventually the Union of the Parliaments in 1707. All actions have consequences, and if James IV had stayed at home, perhaps 500 years on we

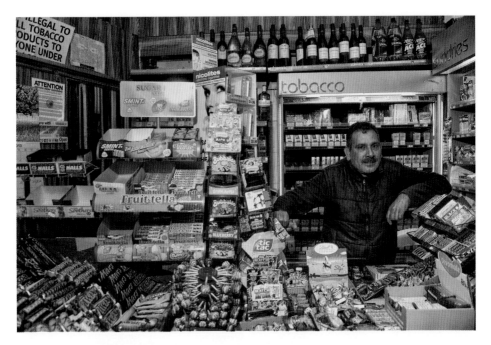

would not be in the middle of an independence campaign, having never lost it in the first place.

WEEK 47
Rajiv at his shop counter, Edinburgh

The man in the corner shop is Rajiv. I see him most days. I have been meaning to take his portrait since the very first week of this project and it is only now, 47 weeks later, that I finally turn up early in the morning, before his shop is besieged by children heading to the primary school along the road.

These little shops are the backbone of so many communities throughout the country. Genuinely 'open all hours', it would be almost unthinkable to be without them, a sentiment clearly not shared by many of the supermarkets, whose slimmed down versions of themselves are appearing everywhere and putting further pressure on the traditional corner shop.

I see Rajiv again on my way to photograph Week 48's images, and leave his shop clutching vital supplies (sweets) for a hard day's photographing up the canal. Canals have always been of interest to me. Even at school I actually quite enjoyed the little bit we did on Scotland's canals. I couldn't believe there were only ever five canals

built here – I assumed there would be hundreds, because they seemed to be everywhere in the books I read and the TV programmes I watched. When I watched television as a kid, people were always either falling in, being pushed in, or being beaten up by The Canal. Basically if a canal made an appearance on *Grange Hill*, *The Professionals*, *Johnny Briggs*, *Coronation Street* or, god forbid, a Public Information Film, nothing good would come of it.

Most of Britain's canals have been in terminal decline for well over a century, but in the last few decades their importance has been rediscovered and huge amounts of money spent to make them navigable once more. The Union canal is now linked to the Forth and Clyde canal via the Falkirk Wheel, allowing travel between the centre of Edinburgh to the Clyde and the west coast once more.

As I walk along the old Union Canal that runs from Edinburgh to Falkirk, it is alive with redevelopment. The new stands shoulder to shoulder with the old and, happily, the old waterway is as busy now as it has been since before the Second World War. It has been here since 1842 and looks like it will be here for a long time yet.

I leave the canal and the central belt, with all its noise and clamour, far behind as I head north once more into the mountains and the forests.

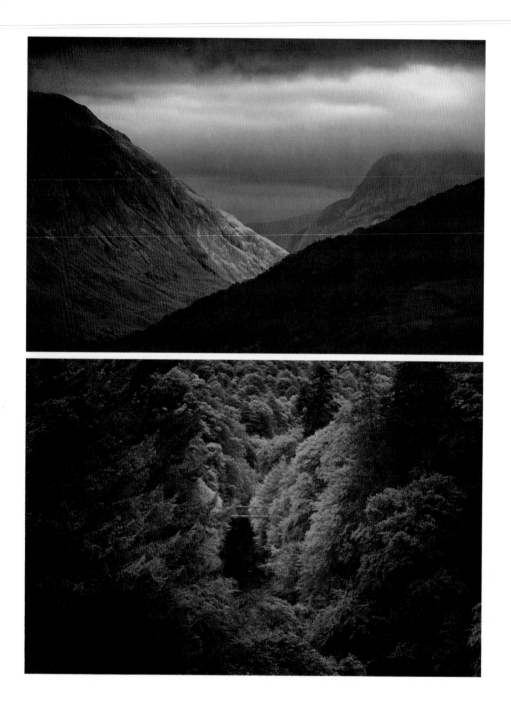

October to November 2013

L ANDSCAPE PHOTOGRAPHY does not come naturally to me. I haven't the patience for it, nor the desire. I enjoy other people's landscape work, but for me it is not something I've spent a great deal of time on. However, I realise that I cannot undertake a photographic portrait of Scotland without capturing at least some of the country's stunning scenery.

Even when I do attempt landscapes I usually find that I include some form of human element, whether it be people or structures, and only rarely am I happy with these images if they have at least something non-natural in them.

On the Ballachulish Bridge, though, I get lucky. Looking out to Glencoe in the east, the morning light catches the hills and illuminates them beautifully against the sky behind, dark and heavy with incoming rain.

I am one week away from the halfway point in my journey now and, slowly, a version of Scotland that I can grasp is becoming clear. Of course, as time goes on, I am becoming convinced that Scotland, and by default any country, can only be defined by a multitude of criteria. Even then it is still entirely vague as to what such criteria might be. Some are obvious: the geography, the history, the culture, the people, etc. Others are less apparent: weather, politics and the attitudes that prevail in society as a whole. The independence debate is revealing that we are a far more complicated country than many would have believed only a year ago. The referendum was barely

WEEK 49
Glencoe from
Ballachulish Bridge

Bridge over the
River Garry,
Perthshire

Below
Picnic, Loch
Tummel,
Perthshire

spoken of when I began, but now, almost a year in, it is dominating Scottish life and I have no doubt it will continue do so up to the vote and very possibly beyond it. It feels more and more like Scotland is waking up from a long political slumber.

I thought it would be apt to mark the midpoint of my project with the search for the midpoint of Scotland itself. Before I began my research into the subject, I naively thought that the centre point would be fairly well agreed on. Not so, as I quickly found out.

I discovered four specific places that seemed to have a reasonable claim to the honour (sorry Harthill Services, but you aren't really the Heart of Scotland) and even these are probably not the true centre point, as the Ordnance Survey makes the point that as coastal erosion and coastal shift are continual, the midpoint would constantly be changing.

Unlike the north, south, east and west points of Scotland, the locations of the possible centre point make no real claim to be so, with the exception of a spot near Newtonmore that has a single small cross carved into a dry stane dyke.

Of the four locations I visited, the one that the Ordnance Survey say is the centre of mainland Scotland is a hillside in Glengoulandie, a few miles east of Schiehallion. This was measured by the centre of gravity method – in other words, if you cut out a map of Scotland and place it on a pin until it is perfectly balanced, that is the centre point. Of course this becomes even more complicated when Scotland's numerous islands are included.

In planning shoots, Google Street View can often be a great place to start my research, and I knew beforehand what to expect at Glengoulandie, which, lovely though the area is, isn't the most visually striking. As I approach the spot, I can't quite believe my luck that some unknown hand has placed a blue arrow road sign pointing almost dead on to the spot on the hillside that marks the centre point. Thank you, whoever you are, you helped make my photo a lot more interesting.

Next claimant is a spot a few miles south of Newtonmore and the only one to boast any form of marker at the spot. On a lonely B road, if you are very observant, you will find a small cross carved into a stone wall. Local legend has it this is the true heart of Scotland. It seems once there was a plaque stating this fact, but

this is now gone. A victim of a jealous plot, I would like to think (have you an alibi Glengoulandie?).

The third contender is a remote area somewhere along the railway line between Blair Atholl and Dalwhinnie. Again, this is based on the centre of gravity method, but this time including all the islands. It is here that the Ordnance Survey last declared the centre to be (in 2002), and it is here, therefore, that the true midpoint probably lies.

Finally, a rather more spurious contender, but without question my favourite of the four. The megalithic Faskally Cottages Standing Stones are a circle of seven stones set with great domesticity in the back garden of a private house. According to a 1908 excavation report by the Society of Antiquities, the exact centre of Scotland was placed here, in this circle of stones, in this well-kept garden. Is it true? Probably not. Should it be true? Definitely yes.

So there we have all the claimants to the honour of being the perfect centre point of Scotland. What I like most about all four places is the almost complete lack of markers or ceremony. There are no visitor centres, cafés or monuments – just a theoretical point on a map that wanders, unfettered and unmarked, through time and space.

Glenfinnan is one of my favourite areas of Scotland. At least it is now, for like so many areas of Scotland, I have never been here

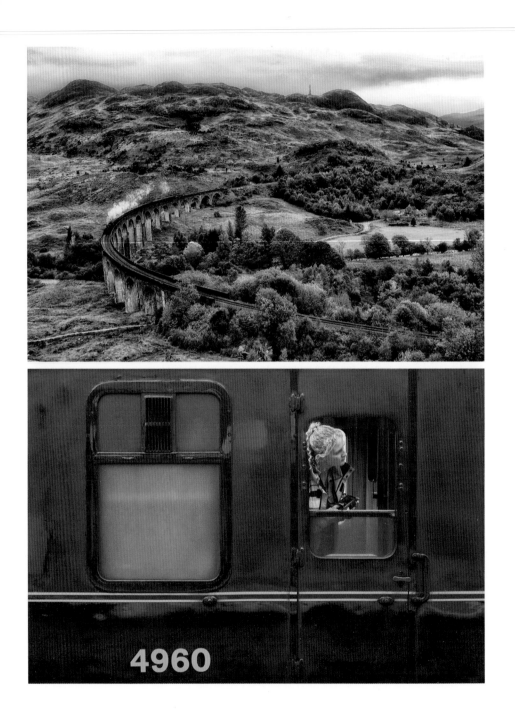

before. From the majestic curve of the imposing Victorian viaduct down past the monument in honour of Charles Edward Stuart (Bonnie Prince Charlie) and out towards Loch Shiel to the south and west, the place has a magical essence to it.

I mistakenly believed that the Glenfinnan Monument was built at the spot where Charles, the Young Pretender, first set foot on Scottish soil, but recently discovered that he first made landfall on Eriskay in the Western Isles and then landed on the mainland a few miles to the west. It was here in Glenfinnan that he first raised his Standard and began the process that would culminate in his defeat at Culloden and subsequent flight into exile in Rome.

Another monument belongs here also – The Glenfinnan Viaduct. This is a monument to the genius and single-mindedness of 19th-century engineering. Built in the last few years of Queen Victoria's reign, it is a stunning sight as it arcs through the Lochaber countryside, carrying the West Highland Line over the glen and then releasing it to snake onward to the port of Mallaig.

I have climbed to a point high above the viaduct to make sure I get the view I am after. I know exactly where I want to be, as I was here yesterday checking on my angles and viewpoint in order to get things absolutely right. The pleasure of having time to plan a photograph is rare, but I have done my homework for once and now know where I need to be and when.

The train can be heard for a long time before it finally appears. The sound of it, the steam and the engine are amplified along the cuttings that the line passes through on its approach to Glenfinnan. Then, with a puff of coal-black smoke that quickly turns into white steam, it appears on the viaduct. The driver slows to a crawl to let the passengers savour the crossing for as long as possible.

Once the train has passed I gather my things and head for Glenfinnan railway station, a mile or two over the hills, where I know a café awaits. It takes me a while to get there, with my dog careering in and out of the bracken as I progress, and when I do I am surprised that the train which crossed

WEEK 51
Glenfinnan Viaduct from below

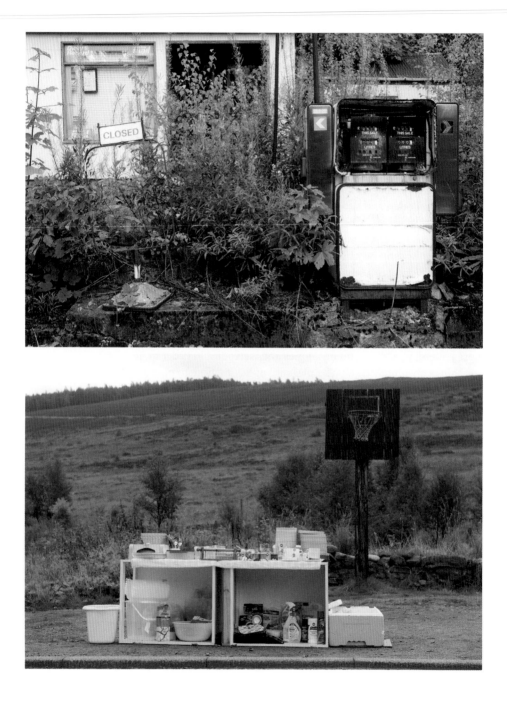

over the viaduct an hour ago is still here. It has let its passengers off to visit the café and the small railway museum in the station. It is just about to leave as I arrive and the passengers, with their heads out of windows, look out down the line that leads to Mallaig and the boat to Skye.

It is exactly a year to the day since I published my first photographs in this series, and realised for the first time what I had let myself in for. Originally I planned to publish just one photograph a week, but foolishly in my first week I used three images and felt I had to continue in the same vein. The project so far has been a lot of work and has involved a lot of travelling, not to mention a very large and still-growing pile of petrol receipts, but far more importantly, it has provided me with a huge amount of enjoyment and wonderment at the beautiful country I live in.

I have had a busy week, with jobs spread all over, so there has been a lot of travelling and effort involved in trying to work out exactly how to get to where I need to be. Instead of travelling by the main roads I decide to take as many minor roads as I can to get to these jobs – those thin, spidery lines on the map that twist and curve over the paper, that have always drawn me in whenever I look at a map.

Smaller roads are perfect for photography as they afford the greatest of luxuries – the ability to stop the car and jump out to grab a quick image, something frustratingly difficult, or completely impossible, on faster trunk roads.

I find myself on the B847, a winding backroad that rises northwards out of peninsula Bridge and skirts lazily around an enormous forest (accurately though unimaginatively called 'Big Wood') before heading to Blair Atholl and beyond. Much to my delight, I discover a disused petrol station in Calvine, where once the main A9 route passed through before being bypassed and presumably sounding the death knell for the garage. Earlier I had passed and photographed a roadside sale from a closing-down coffee shop in the beautifully named village of Trinafour.

Halloween is here and we are besieged by dark legions of tiny ghouls, witches and demons from the blackest realms of our street. I fend them off with handfuls of chocolate, fruit and nuts, and it seems to do the trick, for this year at least.

Guisers on
Halloween,
Edinburgh

Halloween time is a great favourite of mine. I am far more annoyed than an adult should be when the media portray it as a new and modern import from the USA. It may have died out in some areas of Britain, but it never did in Scotland. It has been undead here for centuries and 'guising', as opposed to the North American tradition of 'trick or treating', is as popular now as it ever was.

A few weeks ago on the way to a shoot in Dunfermline, I dropped my dad off in Rosyth, the place where he was born. He wanted to spend an afternoon wandering the streets of his youth. When I picked him up a few hours later he was full of anecdotes about little incidents from his boyhood. I had been thinking about doing something on my hometown of Perth, but couldn't quite work out how to approach it. Listening to my dad, though, I realised that each of us has memories of the places and landmarks of our childhoods that are uniquely personal, yet somehow universal. His memories of Rosyth, though separated by distance and time, were essentially the same as mine from Perth. What linked these memories was their very inconsequentiality. They were such small, unremarkable events, yet to us as small children they are the grains of sand that over the years accumulate the patina and substance which transforms them into the pearls of memory.

In childhood my world was small, but I knew every inch of it; the walk from home to school, the streets, pond and park close to our house were the clearly defined limits of my existence. Within this framework, the early part of my life was played out. This micro-universe tends to exist in the minds of most children, and the physical elements of this universe hold a special significance that is completely lost on the adults that herd and shepherd them so annoyingly when it's 'time for tea'.

The photographs I take this week are shamelessly and unapologetically personal. They are the small, humdrum landmarks from my earliest memories. Each has attached to it equally small and humdrum associations. The first image is of a folly clinging to the edge of Kinnoull Hill that overlook the Tay as it winds its merry way eastward to Dundee and the North Sea beyond. As a child, though, this was a Roman lookout point, isolated amongst the numberless warriors intent on its destruction. It would be years later before I found out it was a 19th-century vanity project to try to make the area look more like the Rhine, studded as it is with hilltop castles.

The second image, 'Glennifer', is somewhere I once walked past every day of my life. It is a door. A door in a wall. There are no sides to it. You can walk round the back and walk through the door onto the street. Or at least I think you can – in all the years I walked past it I never tried. I don't know if the door was locked or open. I don't know if the postman put letters through the letterbox or not. I could never decide if I would technically be a burglar if I walked through the door, so I never did, but it fascinated me then and it fascinates me still.

The long-closed shop at the eastern edge of the old Perth Bridge is another landmark in my memory. The shop itself, even when it was open, was a scary one. I would only ever venture in with my mum. It was supposed to sell everything, but in reality it seemed to sell nothing. Complete with huge old scales for weighing fruit and veg, and lit by the orange light from the acetate sunlight protectors on the windows, it was a fearsome place.

WEEK 54
Kinnoull Hill and
River Tay, Perth

'Glennifer', Perth

The old grocery
shop on Perth
Bridge

The esplanade,
Montrose

Opposite

Pleasureland,
Arbroath

Pease Bay,
Berwickshire

Some of the places and buildings that I remember from my youth are now gone or have changed forever, but many still remain. And although the world I inhabit is much bigger now than it was then, there is a power in these places that has lasted down through all the years of my life and will, for me, end only when I myself am no longer around to remember them.

In Morrissey's 1988 song 'Every Day is Like Sunday' he sings of 'The coastal town, that they forgot to close down,' and 'Every day is like Sunday, every day is silent and grey'. This was my starting point in photographing some of the North Sea coastal towns and resorts on the east coast of Scotland. Like a lot of things, though, the reality is different when I get here. I have always preferred these places in winter. There is a bleakness to them that is quite beautiful, and if you can actually track down a place that is open, it is much easier to get a cup of tea.

When I set out for Montrose and Arbroath, the weather is reassuringly miserable, but by the time I get here it is a wonderful winter's afternoon. Although Morrissey may have been a bit down-in-the-mouth on the esplanade, in Arbroath I am not. The waves

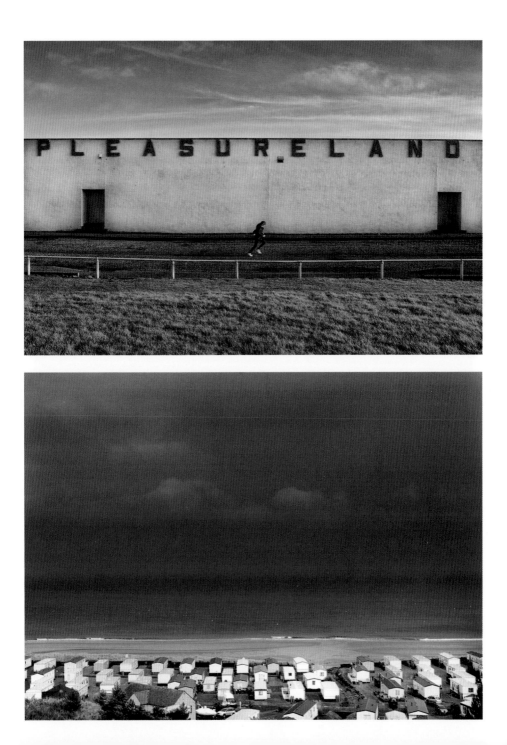

WEEK 56
'The Golden Hour',
Arthur's Seat,
Edinburgh

are thundering onto the seawall and the noise of the gulls wheeling overhead gives it the perfect coastal feel. It is cold enough to keep all but the most intrepid of dog walkers away.

One of the best things about this photography project is that I get to travel throughout Scotland. One of the worst things is that I never seem to have much time when I get there. I have never been to Montrose before, but I like it very much – there is a great mix here of Victorian architecture, Scottish market town and industrial seaport. I could spend all day here with my camera – as it is I have about half an hour. It is another name to add to my growing list of places to revisit.

While the west coast of Scotland is famous for its rugged landscapes, sealochs, mountains and islands, the east coast has a very different beauty – it is the land of the sunrise, and home to a cold and brilliant light. This coast has a rich and bloody history. From the Vikings to the Nazis, conflict has never been far away, lurking just out of sight over those cold North Sea waves. From fishing, whaling and the Hansa trading ports of the Middle Ages,

through to the oil boom of the late 20th century, this coastline has been silent witness to the twists of history.

So, while Morrissey trudges balefully over the wet sands of his coastal town, I will happily wander through the windswept landscape of mine. The seaside is for the winter, not for summer.

The 56th week of my project is a beautiful and cold week, which is wonderful for photography. My favourite time of day has always been 'The Golden Hour'. That loose, indefinable period of time just before true night. Often the sun is already below the horizon, yet much light remains in the sky. The two images I capture are taken from the same place, within moments of each other. One pointing north and the other to the south.

It is a good time to be out and about with a camera, when the light fades and the colour in the sky intensifies. Winter can be a fruitful time for the photographer, as the low sun creates far more interesting effects than the flatter light of summer.

WEEK 56
'The Golden Hour',
Seafield,
Edinburgh

December to January 2014

HAVING THE freedom to explore with my camera is one of the greatest pleasures. To be able to just take off and discover places I have never been to, or to look afresh at places I have, is something I will never tire of. Today, early in the morning, I get in the car and will drive somewhere and see what I photos can get. I am limited as to how far I can go only by the short length of daylight.

I have no real idea where I am going as I start off. I will decide as I go. A while later, I find myself heading along a quiet road that skirts the northern slopes of the Pentland Hills, which are only just emerging from the wave of clouds that had been breaking over them.

WEEK 57
Pentland Hills

Lanarkshire

I drive on through wood and farmland. Pockets of mist still linger, creating strange landscapes that reveal themselves slowly as I approach. Before long, I am on a twisting road through moorland and high forest, looking out onto the Clyde Valley below me.

Onwards I go to Lanark and its old racecourse. Closed in 1977, some buildings remain, while the old scoreboard stands proudly amongst playing fields where once the thundering of hooves sounded. How many eyes in the past looked on it with joy and how many more with disappointment and a discarded betting slip? It stands still, waiting to record the result of a race that will never come.

From Lanark, I head north

through Carluke (I pass a road sign for a town called Bonkle and my teenage self reappears briefly, sniggering) and along the motorway to Airdrie, where I do not want to be. This is the only place I was ever chased through the streets after a football game. My team, St Johnstone, won that day, and some of the home fans seemed to hold me responsible as if I had, wizard-like, reduced their lumbering defenders to stone from my place on the terraces. However, today Airdrie looks different, the old football ground has sadly long gone and the winter light gives it a brittle beauty that I definitely do not remember as I careered through the streets years before.

WEEK 57
The old scoreboard of Lanark Race-course

An old signpost directs drivers to places that no longer exist, near Airdrie

From here I turn eastward and upward, and head for home. Not on the main roads. I take every small country road I can and end up on high moors that lie in a part of Scotland that I have never been to before. This area lies north of the Edinburgh to Glasgow motorway, south of the Edinburgh to Stirling motorway and east of the Glasgow to Stirling motorway. Unless you come this way for a reason, you would pass it by, as I have done many times.

Yet here, on this high plateau, is the mostly undiscovered centre of central Scotland. I spot an old road sign that points to villages long gone, down roads that no longer exist. There were mines here once and now almost nothing of them remains. The sign points east to Stanrigg, where a long-forgotten mining disaster occurred in July 1918. Nineteen miners lost their lives as the mine collapsed after

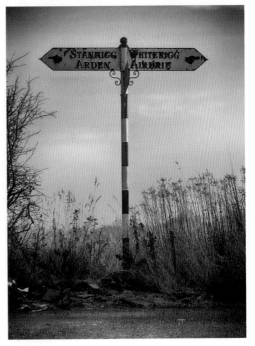

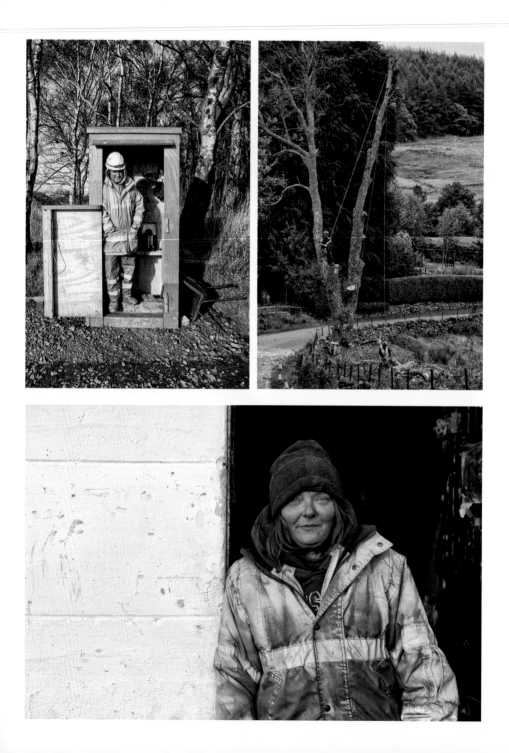

weeks of heavy rain. Eleven bodies were never recovered and still lie there beneath the ground today.

By now, the sun is lowering in the west as I carry on through this high country of moorland and ghosts towards home. Behind me, the sinking sun lights the sky above with evening fire. As the lowlands to the east billow out ahead of me, night falls and I drive on into the growing dark.

Storms have been battering the country again. Outside, the remains of our garden fence lie scattered. Political storms, too, are never far away, and with less than a year to the referendum, Holyrood and Scotland are becoming consumed. Some bemoan the fact that we are even having this debate, while others, myself included, welcome the chance for everybody (and it does feel like everybody) to have their say on how the country is run.

As interesting as the debate may be, it is always a relief to get some respite, and to remember that life carries on regardless of the content of my Twitter feed. Outside, the temperatures are falling rapidly, but life and work continue.

As so often happens, I take a wrong turn on my travels and, heading to Cleland, I spot Eileen, a metal polisher, outside her workshop. I stop to ask directions and as a bonus I get her portrait as well. Scott, working on the under-construction Borders Railway, digs his hands deeper into his pockets as I take his photo. The small sentry-box-cum-hut does not provide much shelter from the biting wind.

I photograph arborists (tree surgeons) in Perthshire and maintenance workers high on electricity pylons in Falkirk. I do not envy them their jobs. I wonder what they think of the referendum. I ask Scott and he replies: 'I can't really be doing with it. I might vote No, I might vote Yes. If this wind keeps up I might not be here to vote at all.'

Although now dominated in the west

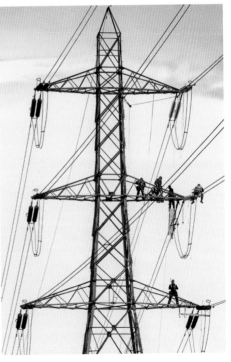

WEEK 58
Construction worker Scott, near Duns

Arborists working near Tummel Bridge, Perthshire

Metal polisher Eileen, Cleland

Below
Electricity workers on a pylon, Falkirk

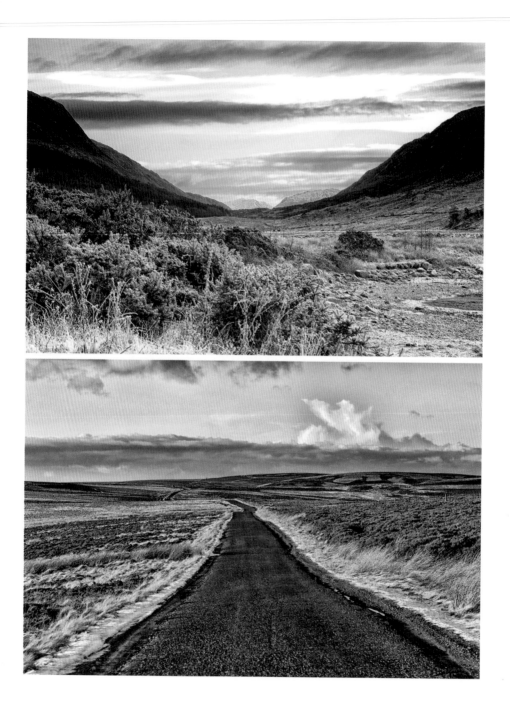

by the Christian festival of Christmas, midwinter has always arguably been the most important time in the calendar of most civilisations, and most peoples, from long before the dawn of recorded history.

Midwinter, specifically the solstice, was always a nervous time for our ancestors. Would the longer days and the warmth come back, or would the sun continue on its downward arc, never to return? It is easy these days to forget the importance of this time in previous ages, but its significance was so strong that even today it is no coincidence that the largest yearly celebration in the northern hemisphere still takes place around the time of the winter solstice.

It can be a bleak time, but it can also be an incredibly beautiful time. I love the dark and brooding days we experience just now (less so the storm winds we have been having) and also the clear, crystal days when the light is sharp and hammer-hard.

There is precious little photography work for me over this period, as everything tends to die off for a good few weeks. This has allowed me that greatest of luxuries – time. Time to get out and about and travel.

I was lucky with the weather – I missed the worst of the gales and seemed to take cold, crisp weather with me. On a whim I decided to revisit Ardnamurchan, and although I don't get as far as I would like due to the shortage of light, I make it as far as Strontian. I last passed this way nearly a year ago, and beautiful though it is in the pale winter light, it is bone-achingly cold.

A few days later I am on a road on the high moor between Gifford and Longformacus, and it is difficult to believe I am only 15 or so miles from Edinburgh, as up here it feels like another world entirely.

Near Longformacus,
Berwickshire

Below

Mist rolls in from the sea at dusk, Leith

Although the days are short, the light is crystal in its clarity. As I approach home, a sea mist crawls over the land and night falls on the shortest day.

The festive season is here. There is a lot of talk about whether or not this will be our last British Christmas, and I wonder if the No campaigners have ever considered trying to bring Santa on board – he would surely be the ultimate vote winner.

Something that was once rare is now becoming more commonplace – the decorating of houses at Christmas. As a child it was unusual enough to be worthy of a feature on *John Craven's Newsround*, but now more and more properties are going for the big neon glitter facade. From the full-frontal assault of the entire house to the stealth approach of the single decorated window in a Leith tower block, it is a sure sign that Christmas is coming.

The other surefire sign of the approach of Yuletide is the pantomime, and the star of all pantomimes is the Dame. Each year the performances remain reasonably similar, but the costumes and

WEEK 60
The big neon glitter of Christmas lights on one home in Edinburgh

A more minimalist approach to Christmas lighting on a tower block in Leith

the jokes change. I travel to many pantos this year to photograph their Dames, and my two favourites are backstage photos of 'Dame' Billy Mack at the Adam Smith Theatre in Kirkcaldy and 'Dame' Robert Read at the Brunton Theatre in Musselburgh.

Hogmanay has now come and gone. Edinburgh is filled with thousands of tourists for the festivities, but I am 400 miles away in rural Wiltshire and miss it all. I come back to a city that has returned to its winter normality. The closes and vennels of the Old Town are quiet once again.

We are now in 2014. Referendum year. The No argument still holds strong in the opinion polls and although the pro-independence side are full of positivity and drive, their popularity level remains stubbornly resistant to any change for the good. It's the New Year, though, and hope is always there.

It's 3 January and I am back at work, shooting in Stirling, where the inevitable wrong turn once again provides a perfect

WEEK 61
'Dame' Billy Mack backstage at the Adam Smith Theatre, Kirkcaldy

'Dame' Robert Read back stage at the Brunton Theatre, Musselburgh

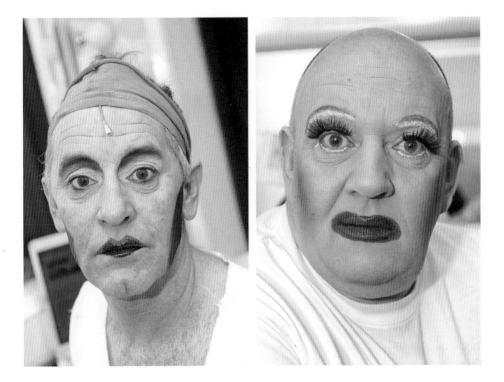

photo. I take my portrait and then I succumb to a haircut (£6.50 – a snip!). Well, it would have been rude not to.

Sometimes when I take photographs, I like to give myself a geographical boundary. This week I wanted to photograph an area I had barely visited or even passed through, despite living only 20 or so miles from it: the part of the country west of Dunfermline, north of the River Forth, east of Alloa and south of the Ochil hills.

I set out with no map, no Satnav, just a rough idea of the area. I knew that if I kept away from the main roads and stuck to the backroads, I wouldn't be disappointed. To travel without a map is surely the finest journey of them all. Are you listening, Scotland?

So it begins. I negotiate the endless dead ends of the dockyard at Rosyth and before long find myself descending a steep hill into the coastal village of Limekilns, whose history stretches back to the 14th century.

WEEK 62
Advocate's Close, Edinburgh

A mobile Barber Shop, Stirling

WEEK 63
Sunset over the Ochil Hills

Onwards I go through the village of Charlestown, before I head inland then loop back to the coast and arrive at the wonderful gem that is Culross. Although tiny, Culross is instantly captivating and its narrow medieval streets, beautifully car-free, seem to have changed little in its long history. I hadn't really intended to spend too long here, but I was taken with the place and didn't really want to leave. Incredibly, it was here in 1575 that the first mine in the world to extend under the sea was constructed. It produced coal for half a century before it was destroyed in a storm and its ruins are still visible at low tide. Many of the buildings boast red roof tiles – a direct result of the village's trade with Holland and the seaports of the Hanseatic League. The tiles were used as ballast holds on ships.

Still, all things must pass, and Culross is soon no more than a half-glimpsed memory in my rearview mirror. I carry on west, past hills of coal that are endlessly consumed by the mighty power station at Longannet (once the largest in Europe) before, at the twin bridges that cross the river at Kincardine, I turn northeast. Soon I am skirting the southern fringes of Devilla forest, where the real Macbeth once fought and won, and Covenanters held secret trysts before turning and heading for the hills.

North now, and with the sun beginning to sink toward the west, I make my way through towns that cling to the southern skirts of the Ochils. Up into the hills past isolated buildings where once barrage balloons rose up during the war, past the racetrack at Knockhill before again heading west and, from on high, I look out across the western Ochils, lit by the light of a dying sun, and the low floodplain of the Forth valley. From here I am told you can almost see to Loch Lomond, far away past Stirling and the Kippen straight. With the light fading fast, I turn for home and leave this mostly undiscovered country behind. For now, at least.

With the luxury of a few free days this week, I decide to head west once more. The weather is beautiful when I leave Edinburgh, all diamond-hard sunlight and crisp blue skies. By the time I make it to the southern edge of Loch Lomond, things have taken a turn for the worse, but no matter – bad weather can make for just as good a photo as fine weather.

I take the road that passes through Helensburgh and head

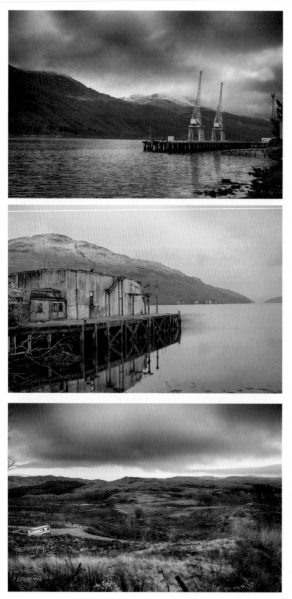

north up the banks of the Gare Loch. Driving along the road, it's not long before the naval base at Faslane appears – industrial and ugly – from the shores. It is then that it really hits home that these rugged and beautiful lochs and mountains are polluted – burrowed full of tunnels in which lurk the malignant objects that are the utter shame of humankind. Nuclear weapons have been stored in these hills, just 25 miles from some of the most densely populated areas of the UK, for decades.

Onwards then, away from this cancer at the heart of Scotland, and up and over to Loch Long before, with a depressing inevitability, more MOD installations at Glenmallan come into view. A jetty and three cranes service a huge ammunitions dump (possibly the largest in Western Europe) that is located in the hills directly above. The Ark Royal berthed here to fill her belly with weapons of mass destruction in 2003 en route to the Iraq War.

I head towards Arrochar and just a mile or so past the town I come across a now abandoned and derelict torpedo testing station, run by the Royal Navy from 1912 until 1986. Here, from tubes under the jetty, torpedoes were fired down Loch Long. This

place, crumbling and ignored, where now I wander at leisure, was to be the downfall of one Augusto Alfredo Roggen, who was accused and found guilty of spying on the facility in 1915. He was hauled to the Tower of London and shot.

With these grim places left far behind, I cut overland towards Loch Fyne and begin the long climb up Glen Croe towards the mountain pass at Rest and Be Thankful, a traditional stopping place for weary travellers after the long ascent up the glen. From here it is not too far along Loch Fyne (and past the always tempting Loch Fyne Oyster Bar) to one of my favourite places, Inveraray. County town of Argyll and home to the Dukes of Argyll, it stands perfectly on the banks of the loch and marks the furthest I have been along this road.

Further west from Inveraray and I enter the ancient kingdom of Dalriada, which 1,500 years ago encompassed large areas of western Scotland and most of County Antrim in Northern Ireland. It is starkly beautiful and feels very remote, even though it is only a few hours from Glasgow. I motor on past the surprisingly small Crinan Canal and am soon at my hotel in Ardfern.

The following morning I find myself on an incredibly potholed and rocky road over to the west coast of the peninsula. The landscape beneath the leaden skies is incredibly bleak and foreboding, and almost completely devoid of human habitation. Much as I love the wild places, I am not too downhearted to finally reach as far west as I can go before turning to begin the long drive home. The huge heavy skies and the vast empty landscape have taken their toll and I am ashamed to say I am happy to return to the world of neon, concrete and steel.

There has been a lot of debate this week as to whether our national poet Robert Burns would be pro-independence or pro-union. Would he be the ultimate celebrity endorsement if, somehow, some proof could be found? There is no way we can say for certain, but I think what we can say with reasonable certainty is that he would be right in the thick of the argument and the debate, enjoying it immensely, whatever side he chose to be on.

The celebrity endorsement has been an interesting facet of the debate. We've had Sean Connery for Yes, David Bowie announcing 'Please stay, Scotland,' through the unlikely medium of Kate

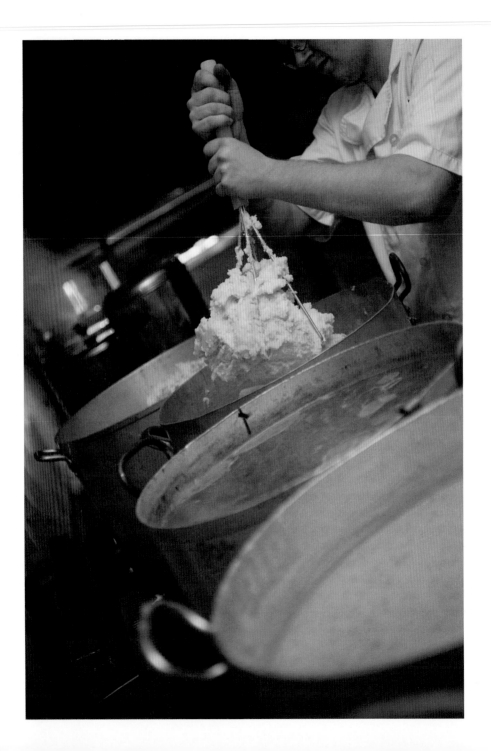

Moss, with and countless others on either side. Few of these celebrities have a vote in any case, so while it's interesting for the gossip columns, their opinions actually have little substance.

I travel to a Burns Supper in Glasgow that has been organised by the actor Iain Robertson and the owners of Guy's Restaurant, which is being held in aid of the Scottish Cot Death Trust. The pop-up kitchen in the venue has to cater for hundreds of guests and to see it swing into action is an impressive sight.

Although informal, the night has all the traditional elements, such as the haggis being piped out, the address to the haggis, the Selkirk Grace and so on. Many Scottish actors, writers, comedians, poets and musicians give performances on what proves to be a very successful night and that, were he still here, the Bard would surely have approved of.

WEEK 65
Food being prepared at a Burns Supper night, Glasgow

Food is served at a Burns Supper night, Glasgow

February to March 2014

SOMETHING RABBIE could not have known about is the railways, invented decades after his death. A new, or to be more precise, renewed railway is due to open in Scotland in 2016. The Waverley Line that once ran from Edinburgh to Carlisle and which, like so many others, fell before the swinging scythe of Dr Beeching in the late '60s is being brought back to life. Renamed the Borders Railway, this monumental civil engineering project is reopening 30 or so miles of track from Edinburgh to Tweedbank, near Galashiels.

I have photographed here many times before in all weathers. It is cold and muddy today, as once more I climb into my fluorescent clothes and steel toe-capped wellington boots and head off down the route that the rails will someday take. Today, the line again reverberates with the sounds of heavy machinery and human voices, as work to reopen the line carries on apace. It is easy to forget where you are amidst the roar of the engines as they move

WEEK 66

Borders Railway
snack van

Borders Railway
construction site

Borders Railway
welder

thousands of tons of earth and rock. I move a little down the line, though, and soon find myself on lonely stretches of the old railway, where the only sounds are the wind and the occasional bleating of sheep from the fields all around. In the silence, it is not hard to imagine the sounds of long ago, when the line was first built using dynamite, picks and shovels.

Colin, who drives me up and down the line in his 4x4, is less excited by the project than I am. Under a barrage of questions he eventually states that, 'Aye, I suppose it's not every day you get to build a railway.' Indeed it is not, as this is only the second railway that will have been built in Scotland in a century.

Even with modern machinery, the line will still take five years to complete. It is testament to the skill and toughness of the 19th-century navvies that they only took three years to build it in the first place.

I gave a talk this week to a group of photography students and the theme was taking photographs of people and places within a five-minute radius of home. Often (unless you live next to Niagara Falls), we completely take for granted the area where we live to the extent that we almost no longer notice it.

As a child I knew the immediate area around my home like the back of my hand – every alleyway, shortcut, climbing tree, loose paving stone, hiding place/ambush place, etc. As we get older and spend less time in our

WEEK 67

An office block, Leith

A man and his dog, Leith

A girl checks her make-up on a bus, Leith

immediate surroundings, other than to pass through them to get to somewhere else, all the little everyday things that as a children we would know intimately now seem invisible.

So I wanted to take a fresh look at my immediate environment and try to see it as if I had never been there before. I live in a quiet street, but what surprises me is how varied the city landscape can be, even within a five-minute radius of my home. It ranges from leafy cycle paths and office blocks to busy city thoroughfares.

What I like about Argyll is how close it is to Glasgow and the central belt, and yet how wonderfully far away it seems to be. Head west out of Glasgow for 20 minutes and you will soon be consumed in a world of hills and mountains, rivers and lochs. What looks like a short drive on the map is anything but that on the ground. The landscape draws you in, and speed, distance and time seem to have less meaning here than they do in the restless atmosphere of endless noise and dirt that is life in the city.

WEEK 68
Rest and Be
Thankful, Argyll

There is still some snow on the crests of the hills and yet, for the first time this year, there is the smallest hint of spring in the air. I stop for a coffee in a roadside café near Dunoon and, sure

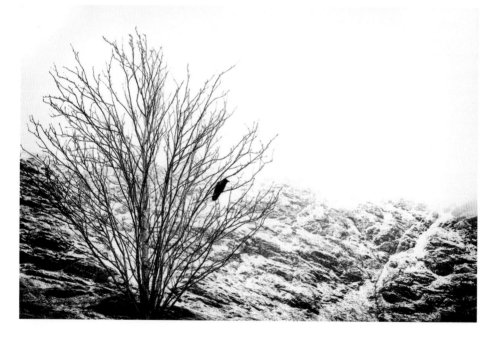

enough, the first conversation I hear is referendum-based. The two women behind the counter are talking in general terms about whether or not Scotland is better in the Union. I ask the about the Trident submarine fleet, which is stationed not too far from where we are. One of the women tells me about her mother, who has bad arthritis: 'There's no money to have specialist nurses, but they have billions to spend on those bloody subs that sail up and down round here.' The other is not so sure: 'I don't know, we need them, don't we? For protection, and jobs.' She is given a quick, piercing look by the other woman and I retreat to my table before I cause an argument. This scene is one I have witnessed wherever I have travelled around Scotland. There is a real thirst to for more information, and it is not the politicians in the first instance that people are turning to. The huge flowering of grassroots movements, particularly, if not overwhelmingly, on the Yes side of the debate have added an entirely new dimension to the political landscape. The usual routes to information through the utterances of politicians and the subsequent reporting in the mainstream media has to some extent been, if not replaced, then certainly

WEEK 68
A streetlight against a brooding sky, Dunoon

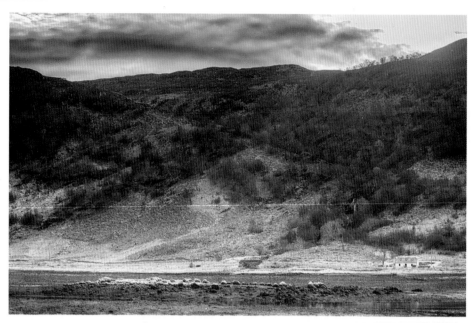

supplemented by a large, vociferous and extremely well-informed social media presence.

This, I suspect, was not foreseen by the main Yes Scotland and Better Together organisations, and the result is that new avenues to information, debate and opinion have been opened up and the referendum campaign is all the better for it. For now, though, I finish my coffee and head back outside into the Argyll evening.

Most people, including myself, know people who have interesting jobs. However, often when I ask people what they do, by the time they have told me their job title I have usually been reduced to a state of glassy-eyed blankness. Often, so have they. It makes me yearn for the simplicity of the Ladybird books I used to read as a child, when seemingly the only jobs people had could be described in a single word: policeman, postman, soldier, fireman, baker, butcher, etc.

In honour of this more innocent time of low-syllable-count job titles, I decide to take some portraits of people with straightforward job titles. There will be no NHS Procurement Officers, Project Managers for Product Development, Business Intelligence Consultants, and certainly no Content Catalyst Co-ordinators!

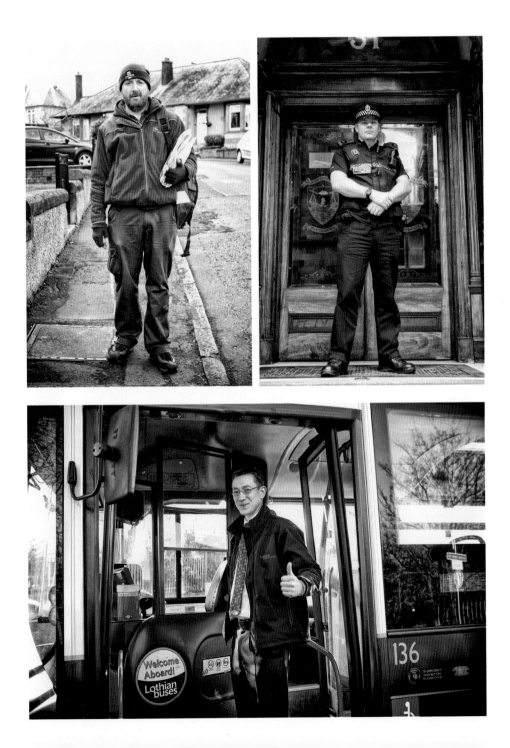

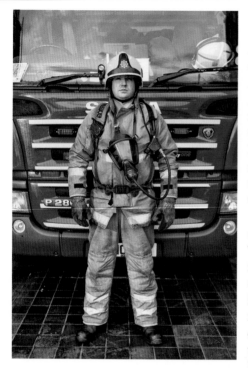

As I walk up to the big glass doors at the entrance to the fire station, I must admit I feel like a five-year-old boy again. Once inside, it really is like a page from my old Ladybird book, *The Fireman* – however, in my excitement I completely forget to ask if they still have a pole that they all slide down. What I do notice is how unbelievably clean the fire engines are – I have never realised this before, but they were absolutely spotless. They are washed at 5am every day.

Then, it's on to my local police station. The station here used to be Leith Town Hall and is an absolutely magnificent building of sweeping staircases and stained-glass windows, and it still boasts the original council chamber room. PC Muir, whom I photograph, couldn't have been nicer in giving up his time and I now feel slightly guilty about laughing when Oor Wullie used to knock PC Murdoch's helmet off up the Stoorie Brae.

Scott the postman is happy to let me photograph him, too. Lord only knows how hard-worked postmen and women must be these days, because whenever I see them they are running from door to door to get the job done. I still occasionally have letters delivered to me that have been re-directed from an address I lived at two house-moves back. These people are very good at their jobs!

To find some examples of job titles that are less clear, I had a quick look on the internet, expecting to find job descriptions such as Management Implementation Consultant. What I find, however, is very different. Some genuinely real job descriptions I stumble upon are: Head of Potatoes, Bear Biologist and Paperfolder, Cat Behaviour Specialist, a man representing the Shredded Cheese Authority and, far and away my favourite, a man described in a BBC TV interview as a 'Writer/ Wizard/ Mall Santa/ Rasputin Impersonator' – it's good to diversify.

WEEK 69

The Fireman

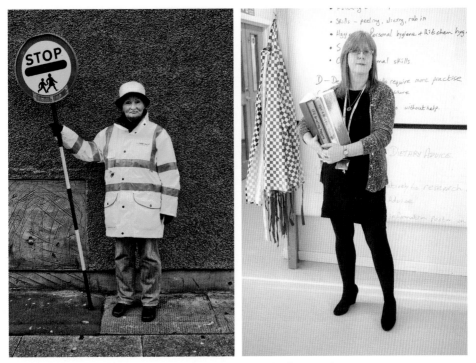

On a freezing-cold morning with a wind straight from an icy Nordic hell, I am wandering the streets in search of a lollipop lady. It took some time, but eventually I find Roberta, who is slap-bang in the middle of her morning shift. I dutifully stand shivering until she is done and am amazed by how busy the job is. I was there for about 40 minutes and not once in that whole time was she not helping people across the road, smiling with the children, or chatting to the parents.

Next, I visit a high school and the memories of my time at school all come flooding back. I have barely been back in a school since I left many years ago now, and the overwhelming urge to run down one of the corridors is overwhelming. Could I? I am still deliberating this when my guide appears and I am led through corridors and stairways to my destination. I photograph Jean in the home economics department, where I half hope I might stumble upon a spare apple crumble. Sadly, I do not.

My third subject this week is Hazel, a geologist for the oil

WEEK 70

The Lollipop Lady

The Teacher

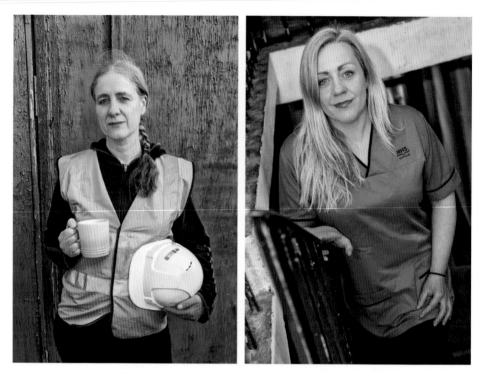

industry. Her busy career takes her all over the world, but I manage to photograph her on a well-deserved break enjoying a cup of tea.

Finally, I photograph Louise, who is a nurse. I have been incredibly lucky in very rarely having to spend any time in hospital. Two years ago, though, I had my appendix out and had to spend about ten days in hospital. To say the nurses and staff were magnificent would be a massive understatement. Perhaps not in my case, but they are literally lifesavers. If I had my way, they would be the highest-paid earners in the land. The NHS is regularly belittled and constantly under threat, yet in my opinion it is the finest, most noble contribution that any country has yet made to the long, stuttering march of civilization. If we lose it, and we might, a light will have gone out that will not be relit.

Scotland has never been short of a writer or two. Throughout our long history, we have produced some of the world's finest,

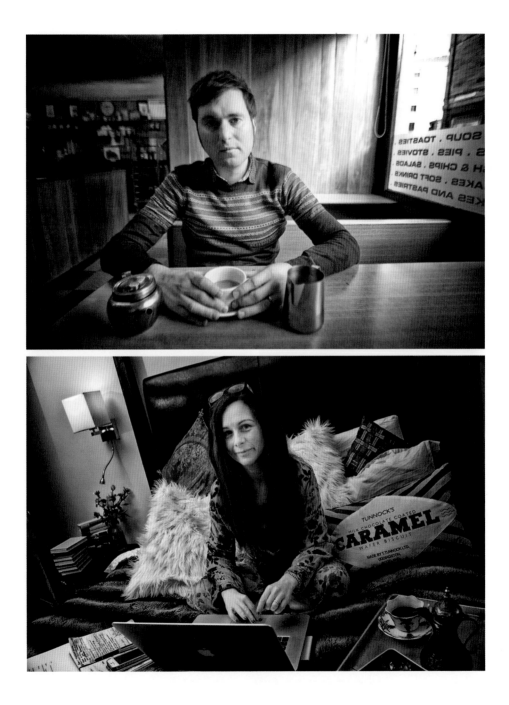

and this trend shows no sign of abating, given the hugely talented crop of writers that we currently possess.

Writers take the pulse of a nation, get to the heart of it, whether that be its demons or its joys. At this special time in our history, much has already been written and much more will be written before the referendum campaign is done.

All the authors I photograph are incredibly generous with their time and each one is an absolute joy to photograph. From Val McDermid's wind-whipped Northumbrian coast to Sara Sheridan's bed, I have thoroughly enjoyed photographing these talented and interesting people.

I begin with Ian Rankin, the hugely successful author of the Rebus series of novels as well, as numerous other works. His latest novel, *Saints of The Shadow Bible*, is proving that his work is as popular as ever, while the TV adaptation, *Rebus*, initially starring John Hannah and latterly Ken Stott, was very well-received. Originally from Cardenden in Fife, Ian lived in London and France, before returning to Scotland. I photographed Ian along the Water of Leith near one of my favourite parts of Edinburgh, the Dean Village, on a day when the first hints of spring were becoming noticeable in the chill Edinburgh air.

Fellow Fifer and Raith Rovers fan Val McDermid has been a stalwart of the literary scene since the publication of her first novel, *Report for Murder*, in 1987. After becoming the first person from a Scottish state school to attend St Hilda's College, Oxford, she went on to work as a journalist before becoming a full-time writer. She is now the author of over 30 books, most recently *The Skeleton Road* and *Bodies of Evidence*. I spent a very pleasant afternoon photographing her near her home in Northumberland, learning a lot of local history, and was provided with an excellent rundown on the merits of the village pubs, which I put to good use before catching my train home.

Playwright and screenwriter Stephen Greenhorn is the creator of *River City* and writer of the award-winning play, *Sunshine on Leith*, and he also wrote the screenplay for its highly acclaimed 2013 film adaptation. He has numerous TV writing credits to his name, including *Glasgow Kiss*, *Dr Who* and *Marchlands* to name a few. For me, though, my favourite work of his is the beautiful play, *Passing*

Places. I saw it several times in the late '90s and it remains one of the finest experiences I have ever had in a theatre.

Since the publication of her first novel, *Truth or Dare*, in 1998, Sara Sheridan gone on to be the author of the Mirabelle Bevan series of crime novels, as well as historical fiction and children's books. Her latest Mirabelle Bevan novel, *England Expects*, is proving to be another big hit for her. I had a lot of fun photographing Sara and once again the time and enthusiasm she gave was hugely appreciated.

Finally, we have the author Daniel Gray. His book, *Homage to Caledonia*, is a powerful work and formed the basis for STV's documentary, *The Scots Who Fought Franco*. He has also written two of the finest football books you will ever read. Both deal with football away from the glamour and the money of the top-flight teams, looking instead at what it means to follow those teams who very rarely, if ever, achieve success. *Stramash* looks at Scottish lower-league teams, while *Hatters, Railwaymen and Knitters* covers the English lower-league teams.

Thirty years ago this week, in March 1984, the miner's strike began. What followed was almost a year of bitterness and deep division, as the Thatcher Government sought and ultimately succeeded in crushing the power of the unions, with little regard to the cost in terms of jobs, lives and communities.

In 1980, coal dug by miners in Ayrshire, Fife or Midlothian could fuel the furnaces of Ravenscraig, which in turn could supply the steel to build cars at Linwood and ships on Clydeside. A dozen years later, the fires of Ravenscraig burned for the last time and the final car had long since rolled off the production line at Linwood. Ships continue to slowly slip into the Clyde, but the glory days of Clydeside shipbuilding are now but a faded memory. During the 1980s, as Thatcherism rode roughshod over anything where the profit margins were deemed to be not high enough, heavy industry in Scotland would see its iron heart ripped out, and it was the coal industry that was hit hardest.

I want to do something to mark the anniversary of the strike, but quickly discover that almost nothing remains of the coal industry today. The collieries have long since closed, filled with concrete and landscaped over with new developments. Trying to

find anything above ground, other than that preserved by mining museums, is almost impossible.

I set off early for Ayrshire to see what remains of the industry there. The road from Edinburgh, once past Lanark, heads southwest through a high country and past the old mining villages of Glenbuck and Muirkirk. The small community of Lugar, which once boasted a huge ironworks (cold and closed for almost a century now), slips by and before long I am on a hilltop in the Ayrshire town of New Cumnock.

WEEK 72
New Cumnock,
Ayrshire

Bowhouse Drive,
where once stood
Seafield Colliery

Uneven concrete steps, broken and cracked, lead up gentle slopes to nowhere in particular. Potholed streets circle aimlessly beneath ruined electric lighting. The pit closed, the people left and the houses were bulldozed. This is a housing estate with no houses and no people.

I head to Fife to visit the location of one of the few collieries I actually

remember. The Seafield pit near Kirkcaldy was a major landmark when I was a child, situated as it was a mile or two from my aunt and uncle's home in Kinghorn. The old road from Kinghorn is as I remember it until, as the road passes under the railway line, the view ahead is no longer of the imposing colliery buildings, but instead of a newly constructed housing estate. All that remains of the Seafield mine is a small plaque, placed low on a metal fence surrounding a children's play park. When the mine opened in 1960, it was claimed that it would have a working life of 150 years. It lasted just 28 years. The coal is still there, millions of tons of it, snaking out beneath the Firth of Forth.

It is Saturday afternoon in Danderhall Miners Welfare and Social Club. Outside, a local football team struggle against a near-hurricane wind. Inside, in the bright and sunlit bar, a few ex-miners gather. It had been a big night the night before at Prestonpans Miners and Social Welfare Club – a large gathering of ex-miners, councillors and

MSPs. I photograph John Barr, who tells me of his time working at Monktonhall Colliery until it closed, and then Longannet Colliery, until it too closed. He had been, and now probably always will be, the last working miner in Danderhall.

What surprised me was just how little of the infrastructure of the coal industry in Scotland remains. It has been almost entirely wiped off the map. Although the buildings and the pit wheels may have been demolished years ago, deep below the ground the coal they were built to extract is still there – and above ground the miners are, too.

Despite growing up in Perth, only 20 miles along the River Tay from Dundee, I have not spent any real time in the city. I have heard a lot about Dundee's regeneration and finally

wanted to spend some time there to see what the fuss was all about.

I was completely blown away by the architecture and buildings – I had no idea whatsoever of the diversity that awaited me and I could easily have spent a lot longer than I did wandering the streets of this hard-but-welcoming city. It was this side of Dundee – the faded buildings and factories and mills – that really excited me. Regeneration is fine, I just find it a lot less interesting to photograph.

Spectacular views can be found on top of Dundee Law, looking south at the city as it nestles between its two great bridges: the road and the rail, with Fife rolling off into the distance in the fragile spring warmth.

Dundee has a very rich industrial background, mostly in jute, and many of the old industrial buildings, although looking a bit worse for wear, still remain. I stumbled upon the Dens Road Market after becoming hopelessly lost trying to find the Tay Bridge. As soon as I drove past the building, the car brakes were slammed on and the camera taken out. This happens a lot. My brake pads are the greatest casualty of this project.

As I wander on, I pass by the clearly closed premises of Robertson's furniture store and take an instant liking to this slightly sorry-looking building, which has been unoccupied since 2011. It is a beautiful building despite, or actually because of it, appearing a bit ragged round the edges. I have parked, slightly

WEEK 73
An aerial view of Dundee

Dens Road Market, Dundee

Robertsons furniture store, Dundee

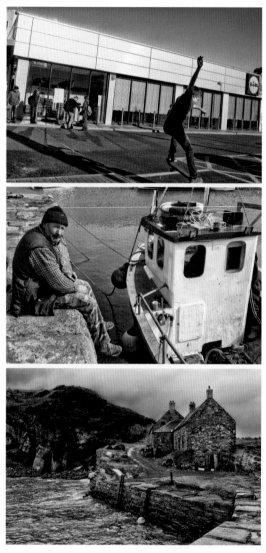

illegally, near Lidl and when I return a school of skateboarders have taken over the area, putting it to much better use than any urban planner would.

I could have spent a lot more time in this incredibly interesting city and will be back soon to explore its many nooks and crannies. It's definitely worth a visit, and is a trip I should have taken years ago.

The southern-east coast of Scotland, between Dunbar and St Abb's Head, is a windy, rugged and beautiful part of the country. It has a bleak majesty all of its own. From the long sandy beaches of East Lothian to the treacherous and imposing cliffs of Berwickshire, this is an area of Scotland that is often bypassed by the headlong rush of the A1 or the clifftop-hugging east coast railway line to London.

The harbour at Dunbar has, over the years, seen many types of goods pass through it, most notably herring in the 19th century and potatoes in the early 20th, and was a major player in the whaling industry. Today there is a bustle around the harbour as numerous small boats are being prepared, ready to set sail in search of the shellfish that today are the main catch in the area. I photograph one of the fishermen as he takes a break from overhauling the engine on his boat.

Further down the coast I stop at Cove, where the harbour must look a little different now than it did centuries ago. I get a real sense that this part of Scotland is waiting for its time to come

WEEK 73
Skaters in Lidl car park, Dundee

Fisherman, Dunbar harbour

Cove harbour

again, instead of being bypassed by history. This sense of waiting is one that I have noticed often on my travels. It feels that wherever I go, there is a sense that something may be about to happen.

Siccar Point, a few miles south of Cove, is one the most important geological sites on the planet. It was here in 1788 that the Scottish geologist James Hutton observed the differing rock strata that provided the proof for the widely held belief that the earth was billions of years old, rather than the few thousand years stated in the Bible. The path along the clifftop is lashed with a shower of hailstones as I walk along it. I soon reach the top of the treacherous route down to Siccar Point. Below me, at the bottom, among the crashing waves, is Hutton's Unconformity, the actual rocks that inspired his theory.

WEEK 74
Huttons
Unconformity,
Siccar Point

A fisherman's hut
in St Abbs

I make it down to the rocks, somehow. Windswept, wet, covered in the rich red mud of Berwickshire and with an aching knee where I have slipped on a boulder, I stand on the narrow shelf of land between the cliffs and the raging North Sea and look around. It all just looks like rocks. Sharp, slippery rocks. I photograph everything I see because I know I will never make this ridiculous journey again. Hutton had correctly surmised that the vertical greywrack rocks must have been warped by volcanic activity and then overlain by the horizontal red sandstone, and that this process could only have taken place over aeons of time. He was a much cleverer man than me – he came by boat.

Located in the fertile and beautiful land between the Trossachs in the north and the Campsie Fells to the south, Arnprior Farm in the small village of Arnprior, a few miles east of Loch Lomond, is a mixed-use farm of sheep, cattle and crops.

February to March 2014

WEEK 75

A lamb being born
on Arnprior Farm

A newborn lamb
on Arnprior Farm

I HAVE BEEN invited to visit the farm by Duncan McEwan and his wife, Rebecca, who run the farm along with Duncan's father, Duncan senior, and his mother, Anne. This is an incredibly busy time of year for sheep farmers and with 600 head of sheep Arnprior Farm is no exception.

Within minutes of arriving I am shown around the lambing pens and given a quick lesson on just how the process works. The pregnant sheep, all due to lamb in the very near future, are kept in communal pens of about 30 sheep. Only a few minutes after the sheep have given birth to their lambs they are moved into individual pens where the mothers bond with their babies and where they can be watched over to check that all is well. Lambs are very susceptible to infection at this stage and are treated with iodine to reduce the risk.

After a day or so, the ewes and their newborn lambs move out of the pens and are taken up into the gentle sloping farmland in the shadow of the Campsie Fells to be released onto the lush spring grassland. After releasing the sheep and the lambs, Duncan stays with them for the mothering-up. He has to ensure that the lambs and their mothers haven't become separated. Later, we will come back to these fields to drop dozens of turnips from the trailer for the flock to eat. The grass is still not really long enough for Duncan to be entirely happy – it has not been warm enough this year.

WEEK 75
Pregnant ewes on their way to the birthing pens on Arnprior Farm

A newborn lamb in a field on Arnprior Farm

Without a doubt, the highlight for me is watching a lamb being born. To see a newborn animal take its first breath is a wonderful thing. The skill of Duncan senior and the trainee vet in delivering the lamb is impressive – I watch as they stroke the lamb, and then very gently insert a piece of straw into the nostril to stimulate the breathing. Within seconds this tiny, greasy little bundle is teetering on legs that seem to want to go in four different directions at once.

For me, the day is over, but as I head off into the fading light I know there will be no rest on the farm. Anne will soon be on the night shift, checking the pens, watching the sheep and delivering more lambs when the time comes.

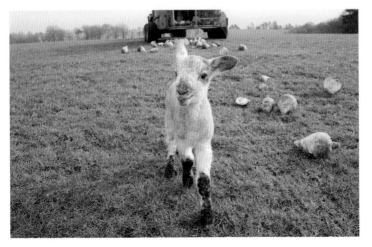

A wind bitter enough to suck the marrow out of bones is whipping the grass all around. I am somewhere in the middle of Sheriffmuir; a high, bleak, blasted moorland that lies, almost inconceivably, barely a few miles from the fertile and lush farmland of Stirling and the Forth Valley. I am standing on a massive reinforced concrete structure that stretches for almost a hundred metres across the boggy ground. I spotted it from the road, set off to the south from where the Ochil Hills rise slowly before their dramatic drop towards Stirlingshire, Clackmannanshire and the Hillfoots. There seems utterly no logic to this structure, here in this landscape that is almost devoid of colour. Yet the solidity, the remoteness, the scale and most of all the absurdity can mean only one thing – the military. What I am standing on is a mock-up of Rommel's Atlantic Wall. The hundreds of miles of concrete, barbed wire and machine guns that stretched so miserably across Denmark, Holland, Belgium and France were recreated here in the early 1940s. Used as a training area, this phony fragment of the Nazi defence of the Continent was subjected to land and aerial attack as the Allies sought to find some way of gaining a foothold on the murderous beaches of Fortress Europe.

Sheriffmuir has seen conflict before, though, and previously it was not a training exercise. A mile or two from where I stand is

another construction of stone and concrete, this time in commemoration of an earlier war – the Jacobite rising of 1715. The Battle of Sheriffmuir took place in November 1715 between the Jacobite forces of the Earl of Mar and the government army, led by the Duke of Argyll. A draw was the official result, although it was seen as a tactical victory for the government. To the 1,500 to 1,600 men killed on both sides, however, it must have felt like nothing more than a bloody and painful defeat.

These are my favourite places. So close, and yet they seem like the far side of the moon. On top of my little piece of the Atlantic Wall I can see for miles – and I swear I can feel for centuries. People and time have moved slowly through this small bit of Scotland – the tides and the storms of history may buffet the lowlands below, yet up here amidst quiet, amidst the moor and the rocks and the hills, none of it seems to make the slightest difference.

It is Good Friday, and it is the nicest day of the year so far. Not a single cloud intrudes upon the perfect cornflower blue of the sky. The road into the mountains, which I thought would have been busy with holiday traffic, is thankfully quiet. As I drive up the western shore of Loch Lomond, I am once again surprised at just how stunningly beautiful it is. The first boats are venturing out onto the glassy water and the day ahead promises to be warm.

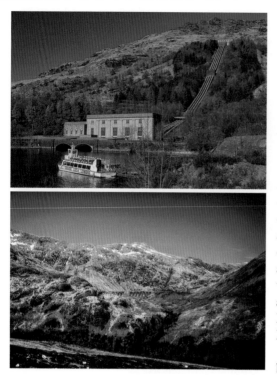

Today, I am planning to photograph some of the imposing hydroelectric infrastructure that delivers so much of the electrical power to Scotland. The architecture of the dams and power stations they feed seems to blend in perfectly with the landscape and are often beautiful buildings in their own right. Was there some form of agreement in the 1950s, when a lot of the infrastructure was built, to create buildings that were architecturally sympathetic to the countryside? Or am I merely looking at it after a gap of 60-odd years, unaware of the massive upheaval and environmental damage these huge engineering projects must have caused at the time?

My first stop is on the 'bonnie, bonnie banks o' Loch Lomond', at

the generating station for the Loch Sloy dam at Inveruglas. The dam at Loch Sloy, nestled high in the mountains above, was built to provide power to the Glasgow area and work began in 1945. Many German prisoners of war worked on the project, including a detachment of ex-SS soldiers who did so little work and who upset the other German prisoners so much that they were sent back to their camps.

I head next to Cruachan, where the inside of the mountain has been hollowed out to house the massive turbines powered by the dam above. From the Cruachan visitor centre it is a short 200m hop across Loch Awe by boat to the area I want to photograph the dam from. However, there never has been a boat here, so the alternative is a 30-mile round trip by car. The weather is wonderful and the scenery is incredible, so it is no chore at all. Before long, I am on the other shore of the Loch, looking north across the water at the dam high in the mountains above. I park

the car and spot a little hill, not too far away across a nice-looking meadow, where I think I will get the best shot.

Ten minutes later and I am up to my thighs in a bog. The lovely meadow that looked so enticing from the car is anything but. Nearby, my dog is apoplectic with pleasure at the great new game her master is playing. I, too, am apoplectic. Covered in mud and soaked through, I struggle to the top of the hill and take my photo. I dry out a little in the sun before I head back where, inevitably, I repeat my mud bath several times.

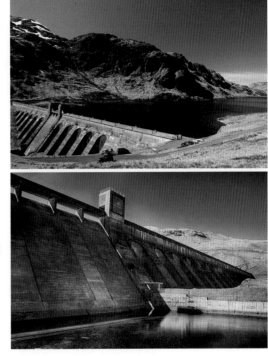

Before long, with my trousers of cracked mud, I am at the spectacular Lawers Dam at Lochan na Lairige. The narrow road I have taken to get here, which winds on through these mountains north to Glen Lyon, is breathtaking and is well worth travelling. I follow it on to Bridge of Balgie and then head west along the river to the Lubreoch Dam at Loch Lyon. I am at the end of the road now. I can go no further west, so I turn and leave this remote and wonderful area to the birds and the sheep.

WEEK 78
Anstruther, Fife

My work now takes me to the Fife fishing village of Anstruther, where on a warm day the colours in the sea and sky are of the deepest blues and greens. Then I am on my way to Stirling, where an ugly goods yard catches my eye, and onwards to Glasgow to photograph the last-ever match played at the dilapidated yet utterly charming Tinto Park that has been home to

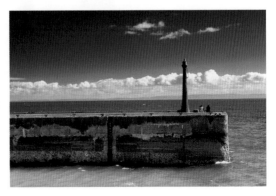

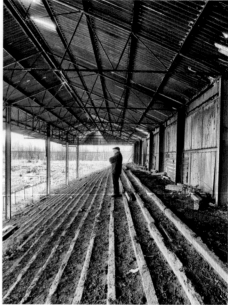

Benburb FC since 1885. Soon the whole area will be flattened for housing and the football club will move on to pastures new. There was a good crowd to say goodbye to the old ground, but my favourite photograph of the day, a man alone with his thoughts, is taken after the match has ended and the majority of the crowd have left. Physical objects may go, but memories always remain.

The road signs welcoming you to Alloa announce: 'Aloha! This is Alloa!'

Of course they don't, sadly. They are missing a golden opportunity to introduce the idea that this small Scottish town is a northern, Clackmannanshire version of a Hawaiian hula heaven. Pity.

WEEK 79
Scenes from Alloa
town centre

To get here, I have passed over one of my favourite Scottish bridges, the Kincardine Bridge, with its imposing 1930s architecture. Decades ago, my grandfather applied for a job operating the swing bridge machinery. He was unsuccessful and was very keen to point out that the fellow who did get the job was a Freemason.

Coming from a small town myself (it now calls itself a city, but

WEEK 79
Alloa Athletic
Football Club

there is little wrong with being a town), I feel an affinity with places like Alloa. These small towns tend to be places that send their sons and daughters off out into the wider world, where in other towns and cities bonds are instantly made with the words, 'I'm from there, too!'

Alloa was – and alas it is a 'was' – famous for being a centre of brewing. At its height there were nine major breweries in the town and Alloa ale slaked the thirsts of men and women in London, the West Indies, Egypt and the Far East. Only one brewery remains today.

The main aim of my visit is simply to photograph as many people as I can. I don't want to get posed shots, rather images of people going about their daily business. Often, asking someone if you can take his or her photo ruins the very thing you wanted to photograph in the first place. The alternative is to take photos as surreptitiously as possible. Otherwise known as stalking, snooping and spying.

I like Alloa very much. It isn't very big, but it feels just big enough. You can walk from the town centre to the harbour, with

WEEK 80
Ian the soundman
at Edinburgh's
Royal Botanic
Gardens

its huge bottling plant, in under ten minutes, passing the large imposing houses that must have once belonged to the merchants and brewery owners of the town. The population of roughly 16,000 all know each other, or at least that is how it seems as I

wander around the town centre. No mischief or extracurricular hanky panky would go unnoticed here, which is possibly why alcohol was once so popular.

I am buried under a mountain of work. As I travel round the country on my photo assignments, I try to photograph what I can to use for my project. In the Royal Botanic Gardens of Edinburgh, a TV show is being filmed and I photograph the sound man between takes. Next, I am at Easter Road and watch as Hibernian FC is relegated to the lower leagues. Understandably, the

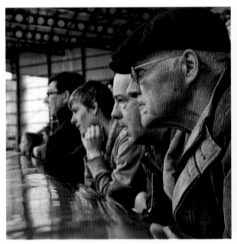

crowd are not happy about it! Next, a charity fun run through in Glasgow is to be photographed and the spectators provide as much entertainment as the runners.

The ferry sways alarmingly while leaving Ardrossan harbour, and the rain falls in sheets from a sky the colour of misery. I begin to wonder if I have chosen the wrong time to be visiting an island off the west coast of Scotland. Arran is a stunningly beautiful

WEEK 80
Fans watching Hibs get relegated at Easter Road, Edinburgh

A spectator with his toy dog at a Glasgow charity fun run

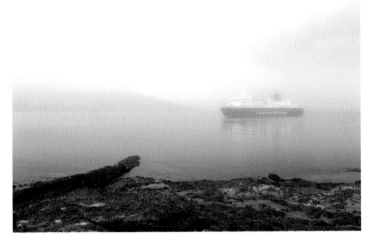

WEEK 81
The Arran ferry cuts through the fog

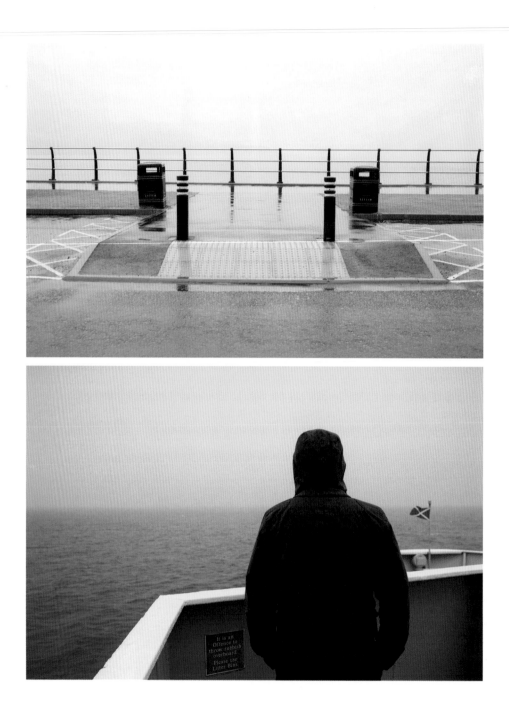

place. Today, however, it is barely visible, and as the boat approaches the main town of Brodick, the thin landmass I saw from a few miles offshore reveals itself on closer inspection to be nothing more than a smudge; a vague watery line between grey skies and even greyer seas.

This is not Arran at its best. The rain is unrelenting for two days and, having no car and being completely unwilling to cycle in the Biblical downpour, I never leave Brodick. My theme quickly becomes 'Scotland in the Rain', one that surprisingly has not featured before.

The rain falls and I venture out. The rain falls and I slosh my way back in again. This is essentially the pattern for my entire stay and, by the end, as I trudge up the gangway to head back to the mainland, I am more than ready to go home. Looking out from the stern of the ferry, the island resembled a forlorn watercolour that had been left out in the rain.

The images from Arran are bleak and grey, which is not really what I want to show. It is a lovely place and when the sun shines it can take your breath away. A year ago I was here and it looked like a small area of heaven. I must have used all my luck up on the last visit, as this weekend has felt only like purgatory.

The Road to the Isles begins at everyone's door. I leave Edinburgh early on a sunny May morning and head against the traffic (always a good sign) towards the Forth Road Bridge and up

WEEK 81
The rain-drenched Arran promenade

The ferry to Arran offering up less stunning scenery than usual

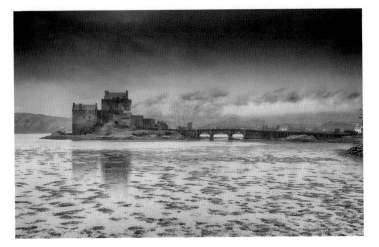

WEEK 82
Eilean Donan Castle

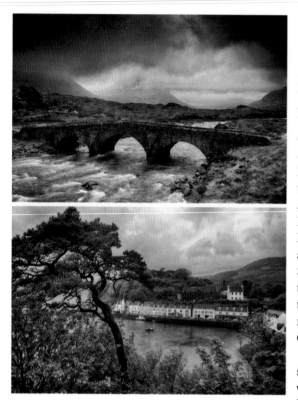

north. As ever, the roads soon decrease in size. At Perth, I leave the motorway network behind at its most northerly point. Dunkeld, Pitlochry and Blair Atholl are quickly passed by before the road rises higher and careers over the Drumochter Summit then down towards Dalwhinnie. Here, I say goodbye to the treacherous yet beautiful A9 as it hurls onwards to Inverness and further north, and head west, where the roads twist and the country grows wild. Spean Bridge spins me off toward Loch Lochy before it, too, slowly falls away, soon to be replaced by other Lochs: Oich, Garry, Loyne and Cluanie.

Then, hemmed in on both sides, I pass through Glen Shiel, where in 1719 a battle took place between those old sparring partners, the Jacobites and the Government Army. Rob Roy, canny as ever, sensed which way the battle was going and withdrew, hurt, from the fight.

I continue west out of Glen Shiel and along Loch Duart before Eilean Donan Castle in all its shortbread-tin splendour appears ahead.

Then, finally, my destination comes into view. I get my first sight of the Isle of Skye through low mist and rain, and it seems like a perfect first introduction. Although the old ferry from the mainland still runs in the summer months, I am keen to get onto the island as quickly as I can and am soon heading over the graceful arc of the Skye Bridge onto Skye itself.

Skye, however, is in no hurry and has no desire to reveal itself to me. Vague, enormous shapes can be glimpsed through the gloom and low clouds. There is a looming presence hidden in the

rain and dark mist that is felt rather than seen, like some crawling night creature that inhabits the deep and disturbed frontierlands of consciousness. The dream-horizons of Skye close in tightly and reveal only the barest flashes of what lies beyond. Even half-glimpsed and half-imagined, the Cuillin – the mighty backbone of Skye – are breathtaking. I am given only the most fleeting, stolen view of the skirts of these ancient and ragged old ladies, but it is enough to know that what remains just out of reach is timeless, majestic and without equal for thousands of miles.

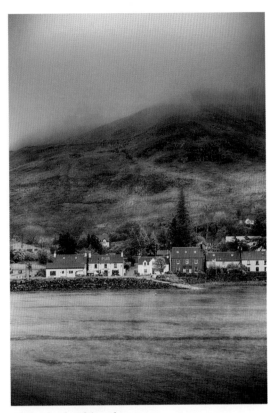

And though the wind howled in from the north and the rain cut like the herring knives that once flashed, slashed and gutted all along the north end of the island, I felt that Skye in this raw and elemental state was how it truly was. The sun will come out and Skye will no doubt shine, but I am glad that on this, my first visit, I was kept at arm's length.

Time is moving on. The debate on the referendum seems to be intensifying by the day. Claims and counterclaims are made. The polls are showing some movement to Yes, although the gap remains a large one. Not unbridgeable, but a hard task nonetheless. Wherever I go, and whoever I speak to, it is never far away from discussion. Scotland at this moment is probably better-informed than it ever has been. People on both sides are being asked to think long and hard about how they are to be governed.

I always make a point of asking the people I photograph which way they are likely to vote – roughly, the results are about 50:50 and, interestingly, despite what the polls say, no one I have spoken to has been undecided. My method is quite unscientific,

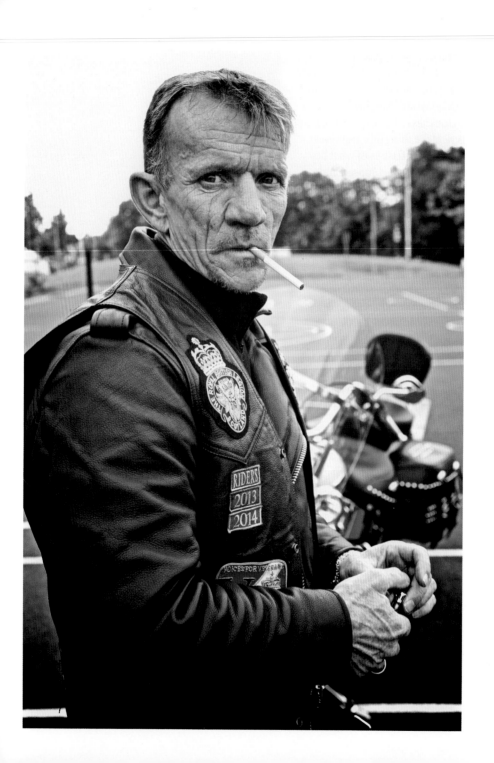

but I have asked people from all over Scotland and from all different age groups. The official polls are putting the Yes vote at somewhere in the high thirties percentage-wise, but I have a feeling it may be larger. Time will tell.

As I get deeper into this project, I am discovering more and more that the idea of any specific 'Scotland' is a fallacy. There are so many facets to this nation that to search for something like 'the soul' of a nation will ultimately be fruitless. It means so many different things to so many different people. The No voter at a meeting Dumfries or the Yes camapaigner leafleting in Inverness may live in the same geographical Scotland, but an entirely separate political one. Which is the real Scotland, I wonder, and does it even matter?

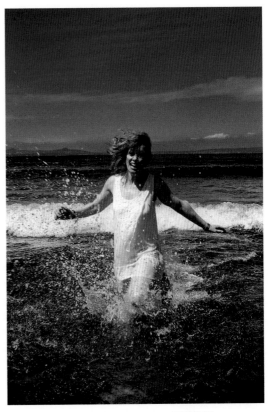

WEEK 83
A biker, Linlithgow

Shonagh Price,
Gullane

June to July 2014

G OVAN: solid, hard, uncompromising. These are the words that spring to the mind when talking about this little area of Glasgow on the southern banks of the Clyde. From Rab C Nesbitt to Alex Ferguson, it is known as the home of the granite-faced Scotsman. However, Govan is more than that. There is more here than the cultural stereotypes of popular myth. It may be the image of a thousand men streaming out of the shipyard gates that has come to define the area, but the history of women in Govan is as engaging and as strong as that of its men. There is a long culture of protest, and it was the women of Govan who led the way, from suffragettes to sit-ins.

It is, first and foremost, ships that Govan is famous for, of course. Here was the beating heart of the Clydeside shipbuilding industry, where they built the ships that built the world. For well over a century the term 'Govan-built' meant absolute quality and excellence.

Yet how little remains today of the places and people who built the ships that girdled the world. At the BAE Fairfield yard on a sunny October day in 2010, HMS *Duncan*, a type 45 Destroyer,

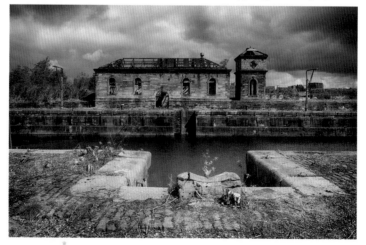

WEEK 84

Old Pump House.
Govan Docks

slipped gracefully, stern-first, into the Clyde. She may well be the last great ship to be launched from Govan, bringing to an end almost two centuries of shipbuilding in the area.

With the future of the Fairfield Yard looking bleak, it would be a hammer blow to Govan if it were to close. There have been hard times here before and somehow the yard has pulled through. Something tells me that despite the gloom, Govan does not give in easily. It may sadly be the case that the last mighty ship has sailed, but with Scotland uniquely placed in Europe for an offshore renewables boom, there may yet be green shoots squeezing up through the well-worn cobbles of the shipyards.

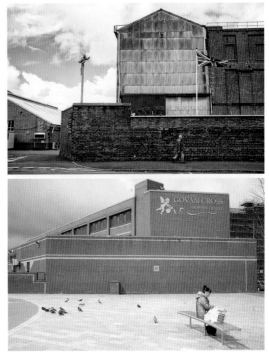

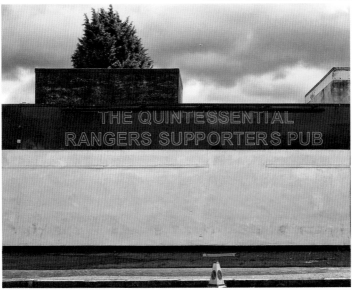

No and Yes
campaigners

Walking around Govan, it feels alive, and the sense of community and local pride is evident. The shipyards, physically and emotionally, are never far away, but there is a sense here that what was once wrenched and shaped out of iron and steel has left too deep a mark to be easily scrubbed out. Govan helped build the industrialised world and it will not allow itself to be forgotten easily.

There are now just 100 days to go until the referendum, and it 85 weeks ago that I started this project on a cold Edinburgh night. Throughout all of this period, both sides of the argument have had their people out on the streets. It seems that everywhere I have travelled there has either been a Yes or a No stall nearby.

All over Scotland, campaigners have been out and about delivering their message. As we approach September's vote, this will increase dramatically. Not even heading to the hills will be safe as, believe me, the hills are alive with the sound of rhetoric.

It is a perfect summer day. I am standing on the shore of Loch

Katrine, deep in the Trossachs. I watch as a gleaming white steamship slips almost noiselessly through the still waters of the loch. The air is heavy with the heat. All around is the low, gentle hum of bees and other insects. Overhead the steady drone of a flying boat can be heard as it skips from loch to loch. And amidst all this beauty and perfection, I am completely devoid of any inspiration.

I have taken quite a few shots, but when I look at them on the back of the camera they don't remotely do justice to what I see and feel all around me. It really does seem like there is absolutely nothing I can do to convey the loveliness of the scene around me. Anything else

than actually being here, at this moment, is just a pale imitation.

The road to Loch Katrine is almost as stunning as the Loch itself. Heading north out of Aberfoyle, the road loops and climbs over the Duke's Pass, through the Achray Forest, and is surely one of the most memorable drives in the country. Shimmering distantly in a warm blue haze are the peaks of Ben Ledi and Benvane. Stretched out below, the forest, verdant and silent, covers all save for the occasional sparkle as the sun catches the waters of Lochs Achray, Drunkie and Venachar. 'There is a pleasure in the pathless woods, there is a rapture on the lonely shore.'

Further along the loch, I find a bit of 1950s industry and suddenly I can take photos again. Quite why the natural beauty of the lochside is, for me, not photographable, while some 60-year-old water facility is, is a mystery. It's just too nice a day to worry about it.

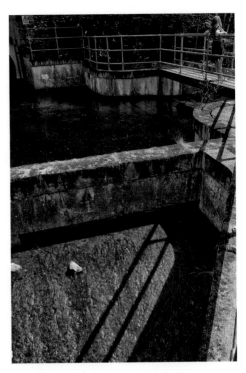

WEEK 86
Waterworks, Loch Katrine

The Vale of Strathmore, lying between the Sidlaw hills to the south and the Grampian mountains to the north is yet another area of Scotland that, prior to beginning this project, I had rarely visited. It is a valley that runs roughly northeast from Perth for some 50 miles towards Stonehaven and is home to some of the most fertile farming land in the country.

My first stop is Coupar Angus, once dominated by a Marshall's Chunky Chicken factory, whose lorries regularly thundered past my childhood home leaving me and other small children covering our noses and gagging in their wake. There is still a chicken processing factory in the town, but technology must have advanced as the lorries smell no more.

I photograph an abandoned railway bridge just outside Coupar Angus. The bridge once crossed the River Isla here before heading

WEEK 87

One of the many footbridges used to cross the river in Alyth, Perthshire

The remains of an old railway bridge over the River Isla, Perthshire

Fairy ring, near Coupar Angus

into Blairgowrie, or Blair as it known locally. I like Blairgowrie. It can be a bit 'interesting' on a Saturday night, but it's a great little town nonetheless. I feel slightly bad that the only photograph I use from the town is of road signs that have been repeatedly assassinated by airgun-wielding Lee Harvey Oswalds, but I just couldn't resist.

Alyth is my last, and favourite, stop. This lovely little town sits beneath Alyth Hill, and is situated on Alyth Burn. This small river can be crossed by many little bridges and the town almost has the feel of Amsterdam and its canals.

The fairy ring I photograph on the way home is a reminder that this area is one that is steeped in the legend and stories of the Gypsy Traveller folk. On dark nights, there would often be mysterious lights weaving in and out of these trees,

WEEK 87
Target practice roadsigns, Blairgowrie

and the sound of laughter and music could be heard on the wind. Come too close, though, and in an instant all would be dark and silent once more...

I had been planning to get to Orkney long before now. It was one of the first places I wanted to go to when I started this project, but somehow, as the weeks passed, it always seemed to be just out of reach. It was with a sense of alarm, then, that I realised how little time I had to organise a trip before the project had run its course. A perfect storm of events meant I had only a tiny window to get to Orkney, and this was reduced further by the fact that I wanted to go by boat, rather than by plane. It just seemed the right way to do it.

So I found myself on a ferry from Aberdeen, heading almost due north into the sunset, so light and short are the nights at this

Pier at nightfall. Orkney
Isles

Buoy, South Ronaldsay,
Orkney Isles

Stone towers on a beach,
Orkney Isles

time of year at these northern latitudes. I have decided for once to leave the car behind and take my bike instead, again probably foolishly, as I will have so little time on Orkney. Once more, though, it just seemed the right way to see the islands.

Before long, I am on the lonely roads of these faraway isles and am completely captivated by their windswept beauty. I always feel that there is a definite shift in the light at these high latitudes. There is a quality here that seems be missing from the mainland. Perhaps it is my imagination, but the muted colours and the soft light make everything seem almost otherworldly.

I cycled, wandered, explored, photographed and island-hopped, and far too soon was heading south once more towards Aberdeen, feeling like I had barely grazed the surface of the Orkney Isles. Like so many places I have visited in the course of this project, it is somewhere I will return to when time is kinder to me. Orkney and its light will still be here when I do – time seems to have less of a hold there.

WEEK 88

The Lighthouse Keeper by the North Ronaldsay Lighthouse, Orkney

First there was one, then two, and soon there will be three. The bridges at South and North Queensferry are the most iconic symbols of Scotland you could hope for.

The two bridges currently crossing the Forth dominate the skyline. There is the world-famous cantilever structure of the Forth Rail Bridge to the east, and the sweeping, graceful geometry of the Forth Road Bridge to the west. A new bridge just upstream of the current road bridge, the Queensferry Crossing, is due to be completed by 2016.

South Queensferry has long been a favourite place of mine. It has undeniable charm and is a mecca for the tourists who come to

view the bridge and take the boat tours out on the river, as well as to the island of Inchcolm, which lies a mile or two downstream. North Queensferry is a quieter place. Calmer and smaller than its more popular twin across the river, it is nonetheless a beautiful place and, for me, offers the best view of the bridge.

To stand beneath the 19th-century genius of the Forth Rail Bridge as the trains trundle by hundreds of feet above is a wonderful experience. How many trains have passed over this bridge, and how many children once thought that the trains drove over the bumps? Although pennies are no longer thrown out of train windows for luck as they cross the bridge, it feels incredibly lucky that such a structure, such a triumph of engineering, has not only survived unscathed two World Wars – the first German bombing raid of the Second World War took place only a couple of miles away at Rosyth – but has been cherished by generations of visitors, and this seems set to continue for many years to come.

Throughout the summer, the borderlands between Scotland and England, this debatable land with its soft rolling hills and secluded valleys, is crossed by horsemen and horsewomen riding out from their border towns, as they have done for at least half a millennia or more.

They come over the prows of distant hills, along ridges and through rivers and streams in honour of those who came before,

A picnic by the
Forth Road Bridge,
North Queensferry

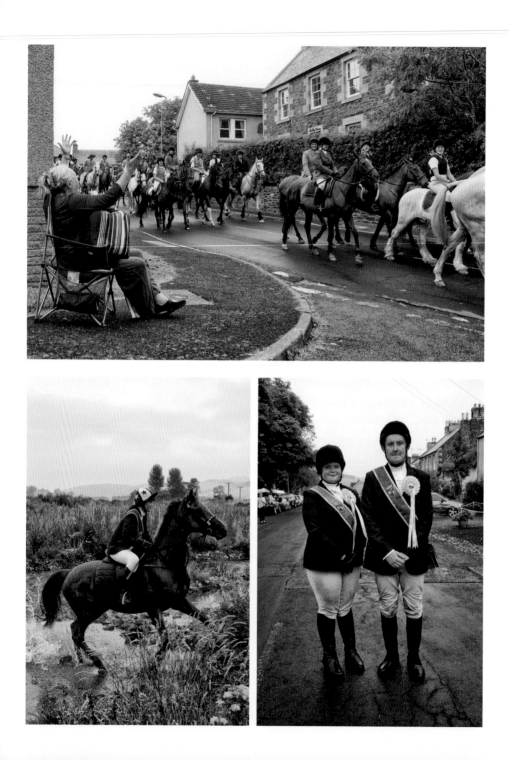

when in more lawless times these common ridings were ridings of the marches. The horsemen would ride out and ensure that the common land belonging to the community was not being encroached upon by neighbouring towns or unwelcome squatters.

Driving through this soft and lovely landscape, it is hard to believe that this was once a lawless and wild land. Home to the Border Reivers, with their fearsome and deserved reputation, it was also the setting for many a cross-border skirmish, or in the case of Flodden in 1513, full-scale battle.

Nowadays, though, only a faint echo of those bloodier days remains. The common ridings hark back to this time when the need for security was crucial. It paid to band together and protect what you had, as many a greedy hand would be ready to seize what was left unprotected.

Today in Yetholm, just a mile or so north of the border, it is a day for picnics on the village green in anticipation of the arrival of the Kelso Riding. The riders have set out early in the day, travelled through other villages and across country before appearing over a ridge on Venchen Hill. Then they begin the descent toward the Bowmont Water and into Kirk Yetholm, and then the larger of the two villages, Town Yetholm.

The Kelso Laddie, with his Right Hand Man and Left Hand Man, then meet with the Yetholm Principals, the Bari Gadgi and the Bari Manushi. These gypsy names come from the two villages' long and continuing association with the Romany community. Legend has it that in 1695, during one of the French wars, the life of a British officer, Captain David Bennet, was saved by his gypsy comrade in arms. In gratitude, he gifted some of his property in Yetholm to the gypsy community in perpetuity.

In 1883, the last Queen of the Gypsies, Esther Faa Blythe, died here.

As the last of the 228 riders that took part this year disappear down the narrow road and out into the country beyond, the village soon returns to its quiet normality. The picnics are packed away under a sky of clouds that threaten at burst any moment. The village hotel is still doing a healthy trade, however, and is likely to continue to do so long into the night.

With the Commonwealth Games kicking off so successfully in Glasgow this week, I had initially thought of photographing the event in all its glory. However, I quickly realise that there would be blanket media coverage, and I felt I wanted to look at it from a different angle.

This week, then, I have travelled back in time to the venue of the 1970 and 1986 Commonwealth Games, Meadowbank Stadium in Edinburgh. When it was initially built, replacing an older football and speedway stadium, it was to have a life expectancy of just one year before it was to be demolished and then rebuilt. Financial constraints meant this never happened, and for almost 45 years the stadium has quietly awaited its fate.

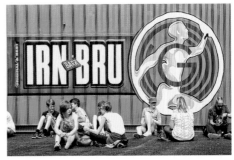

Dancers at Glasgow Green during the Commonwealth Games

Quirky Commonweath Games signage at Polmont Station

The word 'legacy' is often bandied about before major sporting events are staged, and then quickly forgotten afterwards. Meadowbank, however, has been a true example of legacy, long before it became the buzzword so beloved of sports administrators. It has provided many years of multi-use activities and sports. Indeed, with the exception of swimming, it can cater for almost any sport. It has been used for European summits, beer festivals, rock concerts, firework displays and a host of other activities throughout its life, in addition to its main use a major sporting venue for the city. It has played host to most of the world's top athletes at one time or another. Puskas and Bobby Charlton played here in the World Five-a-Side Championships in the early '70s.

Its brutalist 1970s architecture, which would not look out of place in an episode of *Thunderbirds*, has admittedly seen better days, and plans are afoot to finally demolish the stadium and sports halls then rebuild a smaller, more modern complex on the site. The building as it stands is a dream to photograph, all sharp angles and geometry. I have always loved the look of the stadium and will be sad when it's gone, although it is undeniable that change is needed.

Meadowbank Stadium is full of idiosyncrasies and quirks, and is certainly a bit rough round the edges, but while its glory days of Commonwealth Games past are now long gone, the stadium has endured and provided the people of Edinburgh and Scotland with a true legacy. It has catered for almost every sport imaginable in its time and has lasted almost 50 times longer than planned.

August to September 2014

It seemed to last a lot longer than 11 days and was, without exception, a huge success. The 2014 Commonwealth Games in Glasgow will surely linger in the memory of the nation for a very long time indeed. As with London's Olympics In 2012, all of the initial doubts were quickly dispelled, and these (largely) IndyRef-free games captured the imagination of Scotland, and most of all, Glasgow.

The sporting achievements were, of course, at the forefront, with Scotland hauling in a record-breaking catch of 53 medals, but it was the atmosphere outwith the sporting arenas that will live with people for years to come. Glasgow has always been a great city and has nothing to prove, but the place did itself proud during those few days in the summer of 2014. Just to wander the streets and witness the city enjoying itself was a wonderful feeling.

During the Games, the city seems transformed with energy, vitalism, colour and dynamism. From George Square to Glasgow Green and numerous other parts of the city, the 'dear green place' has for the umpteenth time thrown off its long-gone historical image and cemented its place quite rightly as one of the finest cities on the planet. There is a heady atmosphere of pride and celebration here that is incredibly infectious.

As I walk around the city centre, the sun is out and the atmosphere is friendly and relaxed. The mood has caught on throughout the country and

WEEK 92
The Giant Wheel during the Commonwealth Games, Glasgow

WEEK 93

Dudgeon Park,
home to Brora
Rangers Football
Club

Beachside lorry
park, Golspie

even ScotRail has got in on the act, branding many of their stations with Commonwealth Games-related signage.

My first acquaintance with Sutherland came long before I ever went there, while learning about the Highland Clearances at school in 'O' Grade History. These were double periods that lasted only 80 minutes, but they seemed at the time to have taken up most of my life up until that point. The facts went in, to be scribbled down hastily in exams at a later date, before being quickly forgotten and replaced by music, girls, football and absolutely everything and anything else. I was fifteen years old and had no interest in stories of sheep, crofts and empty lands at that time.

But years go by, and there were visits to crofts near Bonar Bridge and to the church at Croick, and long drives through Ross-shire, Cromarty and Caithness. I find that the long-forgotten facts from school are, in fact, not forgotten, as slowly they vividly reappear. The stories of things that happened here and the people that were sinned against never really went away. The Highland Clearances was indeed one of the darkest and most shameful episodes in Scottish history.

On top of Ben Bhraggie, overlooking the town of Golspie, is an enormous statue to the perpetrator in chief of many of the most brutal and most biting of the clearances in this area – the first Duke of Sutherland. Vastly wealthy already, he and his wife, the Duchess of Sutherland, saw more profit to be made by replacing people with sheep and, in doing so, 'improving' the land. What *was* improved was the Duke's wealth, nothing else. Very little, if any, regard was given to those displaced by their actions.

Golspie itself is a quiet and pretty little town which, when I visited, was still festooned with flowers from Gala Week, which had only recently finished. A typical Scottish town, with its long main street of low two-storey houses, painted pale blues and pale browns, hotels, pubs, butchers, fishmongers and one very large fish and chip shop. Golspie Beach is stunning, while inland lies waterfalls and rock-lined walks.

Further north, and Brora springs determinedly from the grey coastline with its long beach, and startlingly small harbour. Once known as the 'Electric City' due it being the only town in the north with electricity (thanks to the presence of a healthy wool industry

Men enjoying the coastal views from Golspie

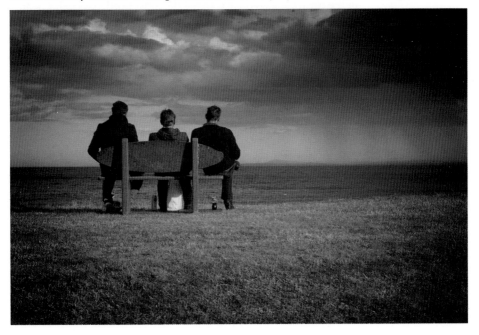

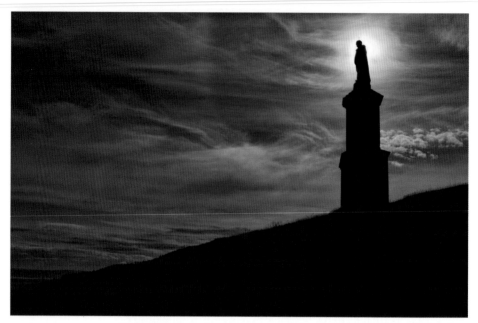

in the town), it also once boasted the most northerly coalmine in the country.

What the Duke of Sutherland could not have known about were the riches that lay beyond the greedy gaze of his statue, out under the cold North Sea. It is oil where the wealth is now be found and which has brought the people back to this area. One day it will run out and the industry will go, but despite all the schemes and avarice of the first Duke, the people will remain.

Julian Cope prowls the stage and holds the audience in the palm of his gauntleted hand. Bearded, peak-capped and leather-clad, he ranges on stage and off, full of lightning vigour and perfect eccentricity. This is not 1979. This is not Eric's in Liverpool. This not The Teardrop Explodes during the first breath of the New Wave. This is 2014 at the Edinburgh International Book Festival.

The independence debate is in full swing and all life is here, from the proponents of change such as Alex Salmond and Alasdair Gray, to their opposites, Gordon Brown and others. Picture this though: the debate does not feature shouting,

accusations or mud-slinging. Time and space is given to all viewpoints and the readings and debates are all the better for it.

Ideas, thoughts and laughter spill out from the various pavilioned rooms in Edinburgh's Charlotte Square, where the Book Festival is held each year. Here, the fourth wave of feminism is discussed. Move silently through the canvas and next door it is The Jesus and Mary Chain who are examined. Move on. Now it is a discussion on gothic ghost stories. William McIlvanney reads with his Ayrshire brogue on the everyday made extraordinary. Here, in the main theatre, Max Hastings will talk movingly on the forgotten horrors endured at the start of the First World War, but for now his audience is taking its seats to the low strains of Deep Purple. In the signing tent, a young man is literally struggling for breath, so overwhelmed is he to clutch the autograph of George R Martin, author of the *Game of Thrones* series. And, amidst all this, small children are making flowers from recycled objects and planting them around the gardens in the venue.

During August in Edinburgh, with the Festival in full swing, if you want comedy, it is here. If you want drama, it is here. So, too, politics, fiction, poetry and sport. The glittering and mirrored Weimar splendour of the Spiegeltent even provides music well into the night.

WEEK 95
Sailors performing
at the Royal
Military Tattoo,
Edinburgh Castle

A few hundred metres away on the esplanade of Edinburgh Castle, the Edinburgh Military Tattoo is in full swing. I have never been before and although it is not high on my list of things to do, a free ticket appears in my hand and curiosity gets the better of me. It is undoubtedly a key fixture of the Festival, and as I approach the Royal Mile I am surprised by the scale of it, though not for a moment by the splendour of the backdrop.

The massed band and the military formation is not really my thing, but it would be almost impossible not to be impressed by the grandeur of it all. The Castle has got to be one of the finest venues on the planet. It is all too easy,

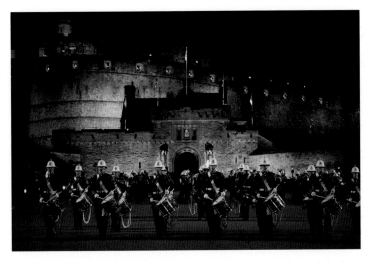

Pipe bands
performing at
the Royal Military
Tattoo, Edinburgh
Castle

living in Edinburgh, to take it for granted, but to see it tonight in
all its glory is a wonderful sight.

I don't really know what to expect from the Tattoo, and to be
honest I'm not entirely sure I will enjoy it. However, it would take
the hardest of hearts not to be completely won over by the sight
and incredible sound of hundreds of pipers and others musicians
playing the theme from *Local Hero*. It will be a long time before I
forget it.

My train batters out of Glasgow Central and clatters over the
bridge, before heading west along the water to the small towns
and ports that cling to the estuary at the mouth of Glasgow's River
Clyde. I am headed away from the noise and dust of the central
belt – not far away, but only a few miles is all it needs to slip into
what can sometimes seem like another world.

Sometimes skirting, sometimes passing directly through,
myriad towns blur past. Towns that still echo with the fading
clamour of their shipbuilding pasts: Govan, Renfrew, Port
Glasgow, Greenock. Next, Gourock, which spreads like a wave up
the hills that overlook the water, with its Art Deco outdoor
swimming pool flashing white against the warm blue of the river
on this sunny yet autumnal August day.

From Gourock, it is all aboard the number 901 bus, which
follows the coast road as it slithers west out of town before

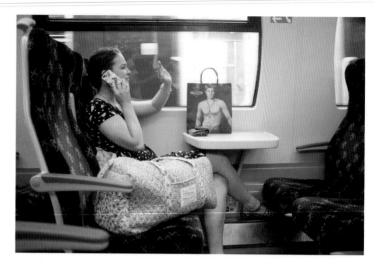

turning south to the resort towns of the Clyde Estuary. On the far coast, the Argyll Forest, Holy Loch (where once lurked the most unholy Polaris nuclear submarine fleet) and Dunoon are visible in the haze across the sapphire-topped waves.

The coastal towns of Inverkip and Wemyss Bay come and go, before my stop at Largs appears through the grime and smudged insects on the bus windscreen. No visit to Largs is complete without ice cream, which is swiftly bought, admired and consumed before a boat, 'the boat', is spotted steaming powerfully towards the quay. Fingers are pointed and arms are held high in welcome. The Waverley Steamship does not hang around and we are no sooner up the gangplank before this magnificent old ship is steamwhistling like a banshee and storming west over the sea. All too soon, I am disembarked upon the Isle of Bute.

After hours of travel, I am, as the crow flies, just 24 miles from the heart of Glasgow. Judging by where I stand, between hills and quiet water, this seems utterly incomprehensible. Its proximity to central Scotland is undeniable – I can see it, it is right there over the water, billowing out in front of me. But this is a purely geographical proximity, for in every other sense it seems perfectly far away, as do I. I sit camera in hand for a moment, not particularly wishing for anything to happen.

As I climb into my old Citroen at 6am on a cold, bright September morning, I realise that this may well be my last longish trip on my '100 Weeks of Scotland' adventure. Fort William is my destination today, and as I head through the clear early morning light a truth I have long believed in seems more true: it is the journey that is the most important thing, not the destination.

Today, the sun is out and Scotland has never looked so beautiful. I spend the journey counting the Yes and No signs that

have sprung up over the last few weeks. There are 20 for 'Yes' and 2 for 'No', although one of the 'No' signs was artistically the best...

Through the Trossachs and on into the north, I make my first U-turn in Lochearnhead, where one of my favourite things, an old garage, has caught my eye. As I carry on, I do my usual thing of being completely astounded by the landscape, and just past Bridge of Orchy I give in. I pull into a stony gap at the side of the road (which may or not be a layby) and take some photos. I'm always astounded by how disappointed I am when I take a landscape shot, as I can never make it look as good as what is laid out gloriously in front of me.

I'm soon in Fort William, and although I prefer the journey to get there, I've always liked the place, so to spend some more time here is not so bad. I have come to do some stills photography for a TV company that is filming a documentary in which my friend, Scottish actor Tony Kearney, will attempt to run the annual Ben Nevis race, as his father and uncle have previously done. The race begins and ends at Claggan Park, the home of Fort William Football Club. When I arrive, it is shinty that is being played, and after watching transfixed at this incredibly skilful form of sporting warfare for a few minutes, I head off to start work.

As the competitors proceed to run like madmen and madwomen all the way to the top of Ben Nevis and back, I wander

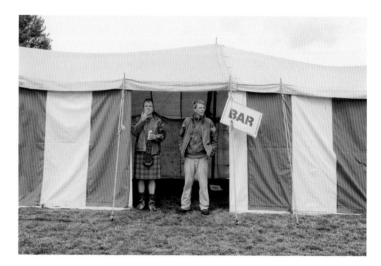

WEEK 97
The makeshift bar
at Claggan Park,
Fort William FC,
for the Ben Nevis
Race.

round and take in the atmosphere. I unintentionally diddle the British Legion out of £1 for a raffle ticket (a foolish mistake) and was pursued relentlessly until I found someone to borrow the quid from. I wander off to look at the replica Model T Ford that is on display, in honour of the one that drove up the mountain in 1911. I was invited to pay another pound and guess the rear tyre pressure, but alas, The Legion has cleaned me out, and now I'll never know.

This fun is soon over, Tony comes roaring in at a magnificent 2hrs 45mins, and before long I am heading south again, on another journey, to another destination. The road goes ever on.

I had thought my trip to Fort William last week would be the last long journey of this project. I'd had an idea to take some photos closer to home, but then at the last moment a trip to North and South Uist materialised out of nowhere. I will have precious little time on the islands, but knowing that I have yet to make a trip to the Hebrides, I know I have no choice but to go.

Once again, then, it is such an early start that it is almost not worth going to bed the night before. As I force myself into wakefulness in the early hours of morning, I wonder again if this is all worth it. Several hours later, I know it is, as I stand close to the prow of the ferry, which is cutting through the grey blue waters of the North Atlantic Ocean, with herring gulls wheeling and screeching overhead. In the

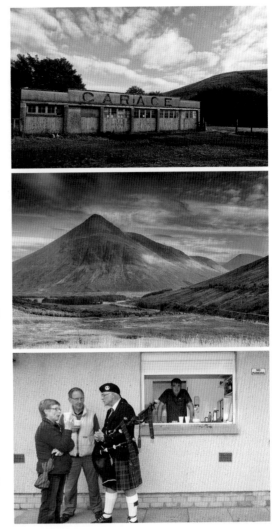

WEEK 97

A disused garage, Lochearnhead

The view north of Bridge of Orchy

Refreshments, Fort William

A dog enjoys the idyllic beach, South Uist

An old fishing boat, North Uist

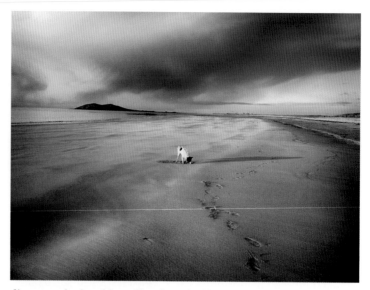

distance, the low blur of land gradually resolves itself into the solid outline of North Uist.

Lochmaddy is where we dock, and before long I am out in the landscape of water, mountain, causeway and machair. It is bleak and yet it seems fragile, almost like a temporary haven between sea and sky.

It is a grey day and the sun does not appear for me. I travel

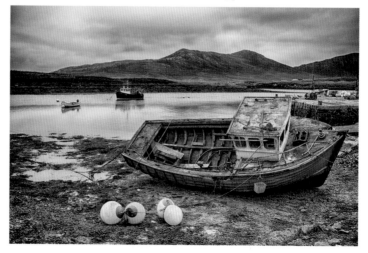

along quiet roads and photograph what I see. It is not a deserted island by any means, and cars pass with more regularity than I had thought they might. As night falls, I plan my morning route over Benbecula to South Uist and then hurry under cover out of the coming dark.

The next day is as beautiful as could be hoped for, and the beaches on the west coast of South Uist are beyond perfect. Long white sands stretch out to the north and south, and a glassy sea lies impassive, almost unmoving, before me. I knew these beaches were special, but to be here in the silence and vastness feels like a blessing.

Later in the day the rain falls and I don't get much opportunity for photography before night falls. I am happy with what I have, though, and sitting in the dark looking west over the inky ocean, past the lonely islands of St Kilda towards Newfoundland, I can feel the distance I have come, both physically in the here and now, and also in terms of my project. Here, on this quiet beach, with the smell of wood-smoke, the whisper of the wind and the taste of malt whisky, I know I am a long, long way from home.

It took a second. Just one second to put a cross in a box. Around the country, millions of other seconds have been used to mark a cross in a small box on a piece of paper in a wooden booth. Those millions of seconds together add up to the will of a nation. The course of a country will change in the space of a second.

I walked to the polling station with my girlfriend, stepdaughter, and four-year-old son in the full knowledge that I was voting for me, for them, for their children, and for unknown and innumerable generations to come. My vote will have repercussions down the centuries and that is a terrifying yet absolutely exhilarating prospect.

Ninety-nine weeks ago it all began. David Cameron and Alex Salmond also leaned over a piece of paper and made their mark. What followed has been the

WEEK 99

The polling stations open, with most entrances flanked by Yes and No representatives

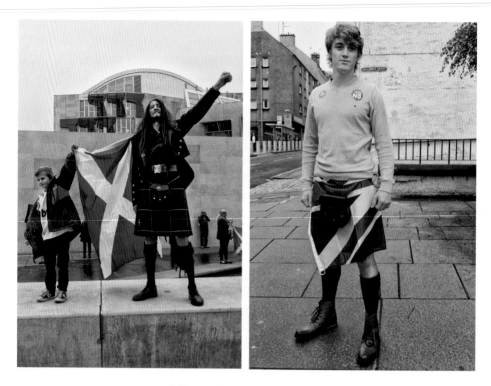

Yes campaigners at
the Scottish
Parliament

A No voter on the
Royal Mile,
Edinburgh

most uplifting and invigorating two years in the history of
Scotland. The debate has reached every corner of the nation.
Wherever I have been in the last few weeks, it is the referendum
that has been the topic of conversation. Do not believe those who
say this has been a bitter time in Scotland's history – it has not
been. Scotland has woken from the political torpor that has
overcome so many western democracies and is alive and buzzing
with ideas and discussion.

This is a historic day. This day will be written about, spoken
about, argued about and sung about for years to come. To be in
Scotland voting today is to be part of history, not as a bystander,
but as an integral part of the process. With a turnout that may be
as high as 90 per cent in places, it can truly be said that with the
eyes of the world firmly on Scotland, it is without question at this
moment the most politically informed nation on Earth. Every last
one of us should be proud of that. Nobody is going into this with

his or her eyes closed. This is, in no uncertain terms, a huge victory for the democratic process.

The polls are closed and the counting is beginning. Two ghost roads have opened up and lie ahead, neither solid yet, but both real. One will resolve itself as the night progresses, and the other will fade. At this moment nobody knows the way ahead, and that to me is an absolutely exhilarating prospect.

Those who bemoan that this ever happened, who complain of a divided nation, need to remember one thing – this is democracy, this is what democracy does and long may it remain so. Scotland, it has been a privilege, a pleasure and an honour.

It is the middle of the night now and the result is in.

Scotland has voted No.

A week goes by and the fallout from the No vote continues. There is much talk of a 'neverendum', as it looks like the extra powers promised by the Westminster political parties may not appear, or if they do, it will be in a much watered-down form. From having crisscrossed the nation for the last few years, I have spoken to many people on both sides, Yes and No, and the desire for more powers for Holyrood is overwhelming. If the Government in London does renege on their promises, and they might, there will be a mighty backlash against them. What was apparent throughout this whole process is that the politicians of the Westminster elite had badly underestimated the strength of feeling in Scotland. If they make the same mistake again, they may not be so lucky a second time.

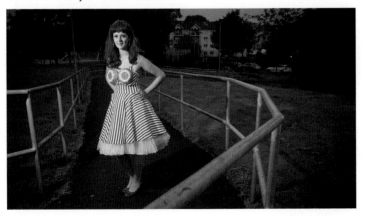

WEEK 99
Lady Alba votes
Yes, Glasgow

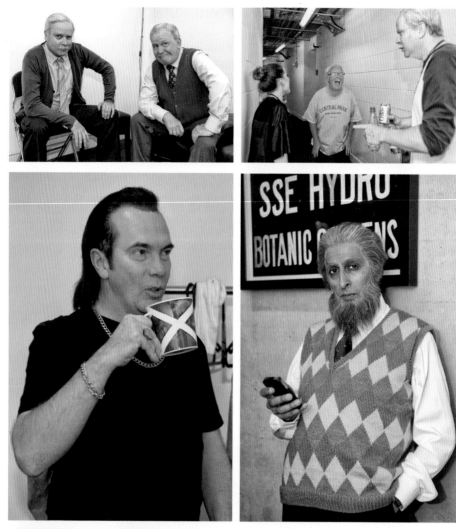

WEEK 100

Clockwise from top left:
Still Game comedy actors Greg Hemphill (Victor) and Ford Kiernan (Jack); Paul Riley (Winston) and Greg Hemphill; Sanjeev Kohli (Naveed); Mark Cox (Tam) and Jane McCarry (Isa); and Gavin Mitchell (Boaby) backstage at the SCE Hydro, Glasgow

Postscript

I THOUGHT FOR a long time about how to finish off this project. I considered a momentous landscape, a sweeping seascape, images of politicians and people coping with the aftermath of the referendum. None of these seemed right, though. I wanted something that was inclusive, that brought people together after a long couple of years. Then, I remembered *Still Game.*

Very rarely does a television sitcom just get everything right. *Still Game* did, and it appeared to do it effortlessly. It was a huge hit when it was screened in the early 2000s, until it left our screens for good in 2007. I first came across it on a cold night at the Brunton Theatre in Musselburgh in the late '90s, when in its first incarnation as a stage play it featured just Greg Hemphill, Ford Kiernan and Paul Riley. From there it grew and grew until, in my opinion, it became the finest comedy series ever produced in Scotland.

When it was announced that it was to return as a stage show once more, it created huge interest. The initial four-night run at the 10,000-capacity SSC Hydro in Glasgow sold out in minutes. More shows were added, and then even more. In the end, 21 sellout shows were confirmed, meaning it would play to an astounding 210,000 people during the run.

I knew it was the right thing to end my project on. As I drove along the Clyde toward the auditorium, the curtain had just dropped on a Saturday matinee show. It was like a football match had just finished, so thick were the crowds. This seemed, naively probably, like a coming together again after a long period of division. There was no agenda here – this was just people out for the fun of it and the simplicity is refreshing after the long slog of the referendum.

No pomp to finish the project. No deep statement or defining image. Just people doing what people do best. Coming together as one, and, if only for a brief period, putting their differences aside and laughing. Laughing a lot.

I started out to photograph Scotland, to try to get a feel for the nation and its people, in the momentous 100-week build up to the

referendum. What I discovered is that there are a multitude of Scotlands. It is, like all countries, an amalgam of its history, its geography, its politics, its attitudes and, most of all, its people. The Scotland in the head of a cab driver in Dumfries may not be the same as the Scotland in the head of a fisherman hauling in his catch on the North Sea. They may share the same nation in time and space, but other than that their countries are not the same. This is not a fault – this is the very thing that makes all countries what they are. The Scotland I found was beautiful and ugly, happy and miserable, outward looking and insular. But most of all it is a country where people are just trying to get by in whichever way they can. Scotland is a wonderful place. I love it, not because it is better than anywhere else, but because it is the same.

Since beginning this project I have covered enough miles to take me round the entire planet. I have travelled to the four corners of the land and it has been a joy and a privilege. I have met many wonderful people and seen many breathtaking sights. I have learnt so much about the country and heard many of its stories. And I have still only seen a fraction of the whole.

The most important thing I have discovered, though, is this simple truth: Scotland is, in every way, a much bigger place than it could ever appear on any map.